Tony Bennett

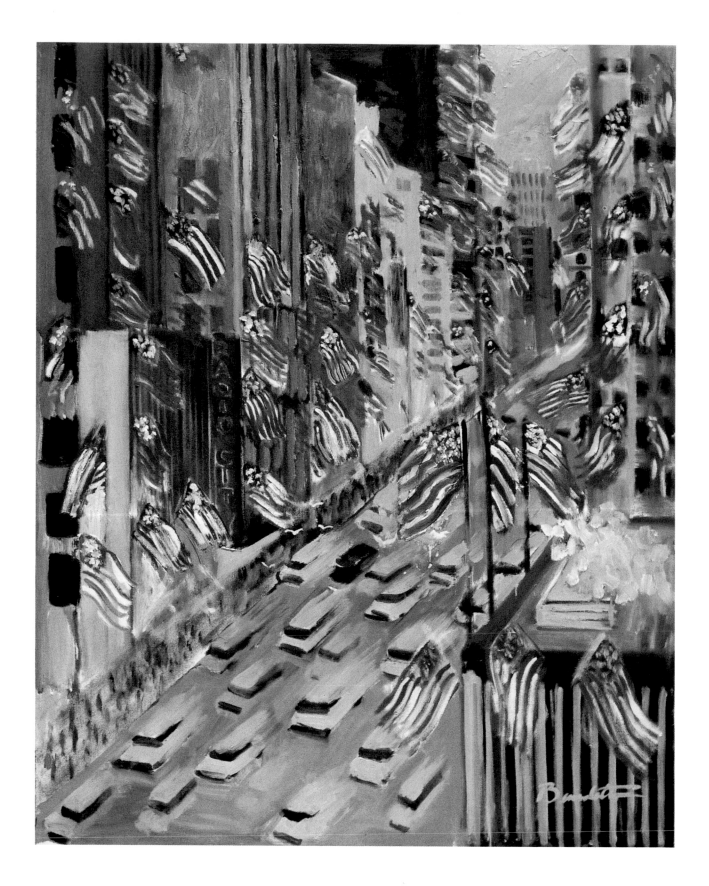

Avenue of the Americas
oil on canvas
31 x 20 inches

What My Heart Has Seen

Tony Bennett

Introduction by Ralph Sharon

RIZZOLI
NEW YORK

First published in the United States of America in 1996 by

Rizzoli International Publications, Inc.
300 Park Avenue South
New York, New York 10010

Library of Congress Cataloging-in-Publication Data

Bennett, Tony, 1926–
 What my heart has seen: Tony Bennett /by Tony Bennett:
introduction by Ralph Sharon.
 p. cm.
Includes index
ISBN 0-8478-1972-8
1. Bennett, Tony, 1926– —Catalogs. 2. Musicians as artists—
United States—Catalogs. I. Title.
N6537.B4552A4 1996
759.13—dc20 96-7913
 CIP

Designed by Sisco & Evans, New York

Printed and bound in Italy

Contents

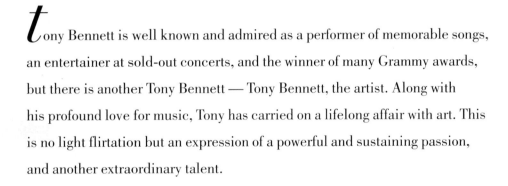

Introduction

*t*ony Bennett is well known and admired as a performer of memorable songs, an entertainer at sold-out concerts, and the winner of many Grammy awards, but there is another Tony Bennett — Tony Bennett, the artist. Along with his profound love for music, Tony has carried on a lifelong affair with art. This is no light flirtation but an expression of a powerful and sustaining passion, and another extraordinary talent.

Anthony Dominick Benedetto was born on August 3, 1926, in Long Island City when the Great Depression was already beginning to loom over the country. Many years later he changed his name for the marquee to Tony Bennett, but he has always signed his art works *Benedetto*.

The Benedettos, like most Italian families, were fond of music and Tony could sing almost as soon as he could speak. On Sundays, when the family got together with aunts and uncles, someone would grab a guitar and the singing would begin. Tony's brother John favored opera and would give out with his version of Puccini or Verdi arias. He was called "Little Caruso" and performed solos at the Metropolitan Opera at age fourteen. Not to compete with his older brother,

Above: Mary, John, and Anthony Dominick Benedetto, summer 1928.

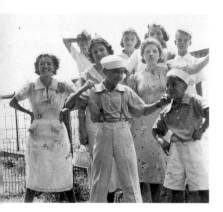

Tony offered another style of entertainment, imitating Eddie Cantor, Al Jolson, and Bing Crosby with surprising accuracy.

Tony's first official performance took place at the age of seven at the ceremonial opening of New York's Triborough Bridge. Walking with Mayor Fiorello LaGuardia, followed by a throng of people, Tony sang "Marching Along Together." To this day it remains one of his fondest early memories.

When Tony was ten years old, his father died and the family's circumstances changed. With his mother going to work and his siblings busy with their own lives, Tony found himself alone for many quiet hours. Drawing, sketching, and even cartooning became important afternoon activities for him. While other children would doodle, Tony would try to "get the picture right." One of his significant childhood memories is of sitting on the sidewalk one day trying to create a Thanksgiving mural with a set of chalks that his mother had bought him. Engrossed in his work, Tony did not at first notice the shadow of a tall man standing behind him. "That's pretty good. You keep it up. Your work shows promise," said a voice. It was James McWhinney, an art teacher who lived in the same building, who, from that moment on, took Tony under his wing and taught him all he knew about watercolor and oil painting. To this day Tony attributes his passionate devotion to art to his mentor. Each time he picks up a paintbrush,

Above: Tony with fellow soldiers after the Second World War. Left: Tony with friends by the sea.

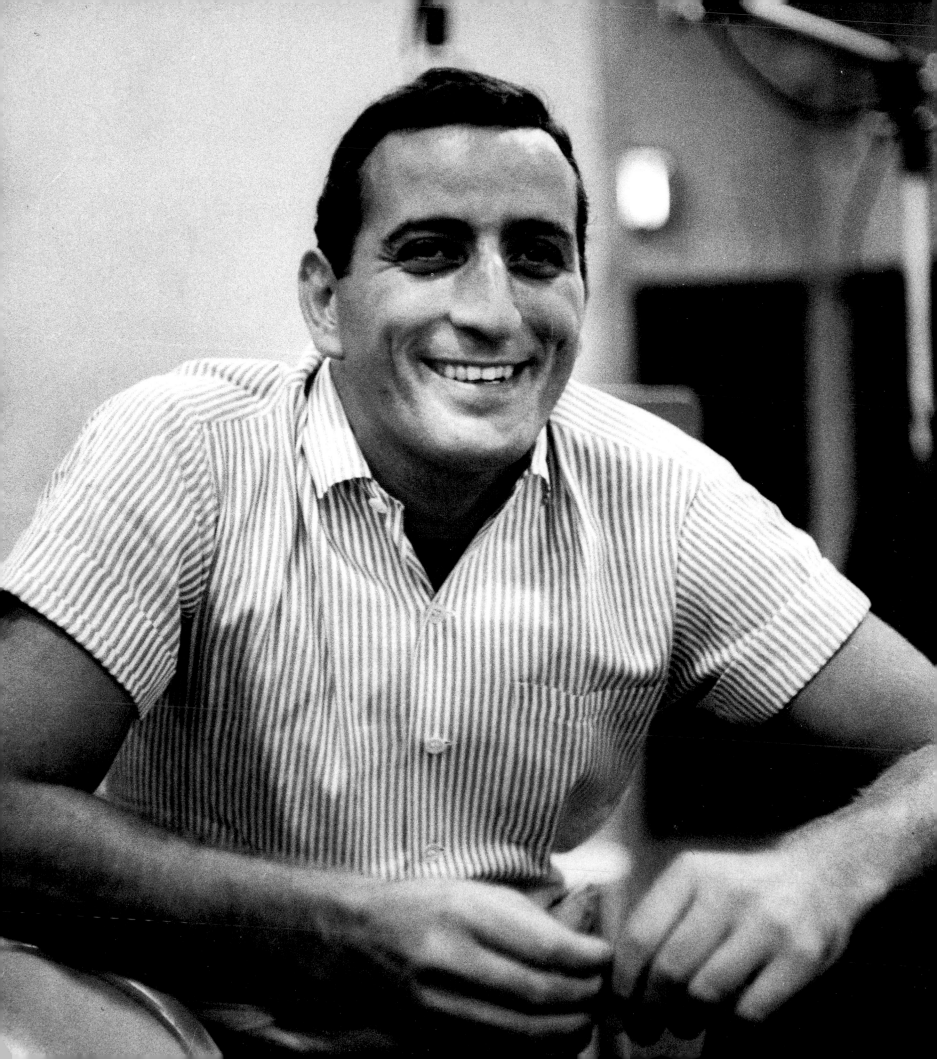

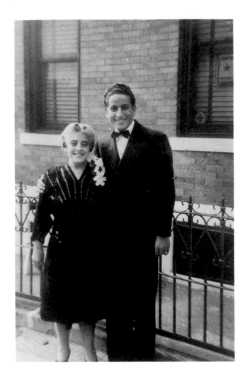

he feels the influence and joy instilled in him by his first "professor." Tony's artistic talents grew alongside his interest in music and the two have been inseparable ever since.

During his teens, Tony attended the High School of Industrial Arts, a public school in New York. Supported in his ambition by his family, he was intent on a career as a commercial artist.

In 1944, when he had turned eighteen, Tony was drafted into the army and after some basic training he was shipped out to Germany. Stationed in Mannheim with the 63rd Infantry, he made good friends among the soldiers and one evening he invited a black man to dine with him at the Officers Club. This invoked the full fury of the officer in charge, in whose opinion Tony had disgraced the uniform by keeping black company. With his corporal's stripes ripped off, Tony was told to report to "Graves Registration"— the most grueling task for any soldier. Rescue came in the guise of Major Lefkowitz, who intervened on Tony's behalf and offered him the post as singer and librarian with the Armed Forces Network Orchestra. Tony never forgot this troubling incident and years later was proud to join Dr. Martin Luther King, Jr. on his historic march for racial equality in Selma, Alabama.

Discharged from the army in 1946, Tony returned to New York and soon, on a grant, entered the American Theater Wing—the forerunner of Lee Strasberg's Actors Studio. It was here Tony learned technique: how to control his breathing, measure a phrase, polish his pronounciation and diction, and care for and pre-serve his voice when not singing—all while he continued to sketch and paint, a pleasure he had not neglected even during two years in the army.

In the hope of finding an outlet for his desire to perform, Tony began to hang around the clubs that were doing a booming business as a result of the war's end. Sitting at the bar one evening at the Shangri-La club in Astoria, trombone player Tyree Glenn asked Tony to come up and sing with the band. What a thrill! Tony was hooked. His first professional engagement was at this club and in order to continue, he soon took a job as a singing waiter at Ricardo's, where well

Above: Tony with his mother, Anna.

performed requests would produce good tips. Two Irish waiters, whom Tony still remembers with gratitude, would sneak him into the kitchen and help him memorize the lyrics to popular songs such as "Danny Boy" and "I'll Get By."

From the Astoria "saloons" Tony journeyed downtown to the small, smoke-filled "joints" of Greenwich Village. This was where people would come to listen to new talent. Pearl Bailey came to one of the clubs one night and liked what she heard and recommended Tony to Bob Hope. When the two met, Tony introduced himself as Anthony Dominick Benedetto. "That's too long for the marquee. Let's call you Tony Bennett," Bob Hope replied. This was the moment of dramatic change. Tony joined Bob Hope's show at the Paramount Theater, where he shared the bill with Jane Russell and Les Brown and his great band.

When Tony signed a contract with Columbia Records in 1952, he had no idea that this association would last over forty years and result in recording more than ninety albums that have become a staple of popular music of our time. Whether "Because of You," "Rags to Riches," or "I Left My Heart in San Francisco," everyone has a favorite Tony Bennett song. The successful recordings naturally enough led to personal appearances, first at nightclubs and then at Carnegie Hall in 1962. Slowly but surely Tony emerged as the consummate communicator of the classic American popular song.

Although Tony Bennett is known all over the world as a popular singer, he has always regarded himself as a painter. As far back as he can remember, he

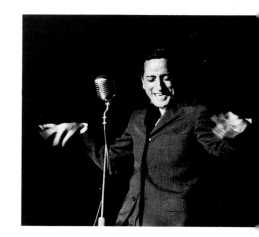

Above: Tony with Dizzy Gillespie, 1992.

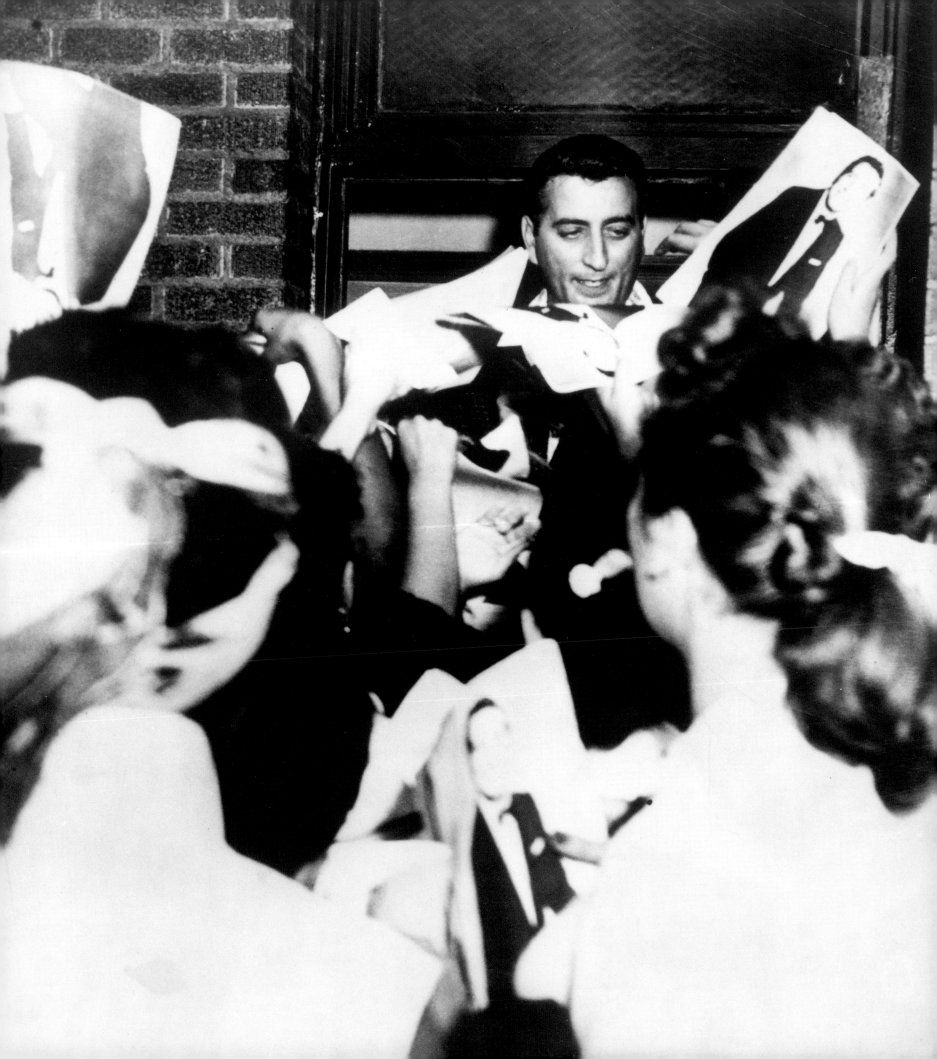

knew what he wanted to do, to sing and to paint. Because he never knows when inspiration will hit, he carries a sketch pad and pen or pencil with him at all times. He sketches in planes, in airports, in limos, in hotel rooms, at breakfast, lunch, anytime, anyplace. From his sketches come his paintings, and his apartment in New York City is filled with paints and easels.

As a performer, Tony Bennett has been fortunate to be able to entertain audiences the world over. For the past forty-five years, he has been compiling his sketches and paintings into a visual diary of all the cities he has visited and all the fascinating people he has met along the way. Indeed, painting is becoming his second profession, but it remains his first love. Tony tells us, "I feel blessed to be an artist and honored to be part of the 'brotherhood of painters.' I consider them the best society in the world."

Tony Bennett has often dreamed of compiling his artwork into a book, but he never thought his dream would be realized. By chance, his eight-year-old granddaughter Remy Bennett and her friend Elizabeth were talking one day about what their mothers did. When Elizabeth said that her mom worked at a publishing company that specializes in art books, Remy exclaimed: "Art books! My grandfather is an artist!" A short time later, Danny Bennett, Tony's son and manager, was approached regarding the publication of a book. So with added thanks to his granddaughter we present Tony Bennett's book, which he has chosen to entitle *What My Heart Has Seen*.

Ralph Sharon, Los Angeles, California, 1995

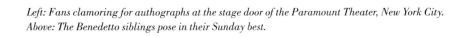

Left: Fans clamoring for authographs at the stage door of the Paramount Theater, New York City.
Above: The Benedetto siblings pose in their Sunday best.

New York, New York

W hether it is the Bronx or the Battery, the heartbeat of New York is my heartbeat, for I was born with a view of one of the greatest cities in the world. The pulse of New York has always been a creative force both in my music and in my art. At any time of day there is a tremendous surge of energy here that I can find in no other city anywhere. Where else at 4 AM could I find a jazz club just hitting its high notes, a street artist putting his final brushstrokes on a scene of "A Night on Park Avenue," or a line of people a mile long waiting for corned beef on rye?

A cliche about New York City says: "It's a great place to visit, but I wouldn't want to live there." Well, I do live here and I love it, but I am also able to share in the excitement of the visitor. My profession takes me out of town for weeks on end, and when I return, I sometimes feel like a visitor in my own city, and like a visitor, I get to appreciate, again and again, all that New York has to offer. As a kid I never dreamed that I'd be lucky enough to have an apartment in the heart of Manhattan, but I do, and it overlooks Central Park, no less! Amid the hustle and bustle of this great city I find a very relaxing, warm, and inspiring atmosphere. The intensity of men and women making

Left: Early nightclub singing. Above: New York, 1985.

their determined way to and from work, and the evening crowds rushing for an 8 PM curtain time at a Broadway show, seem to charge the air with excitement, and as you look around you realize that you are alive. This is my personal "Lullaby of Broadway." To me, New York is the greatest university in the world, with the accent on culture in its curriculum.

Everyone remembers their first trip to the Big Apple—the Empire State Building, the Statue of Liberty, chestnuts roasting on a street cart near Radio City Music Hall, to name a few familiar sights. I walk out of my building and into all that commotion. How could I not paint in this city? The invitation to pay it honor meets me at every street corner. Instead of remembering just a few spots, I paint it all—even the taxicabs are a thing of beauty in this glorious city. At times, with my sketch pad in hand, I've taken a stroll in Central Park and I've come away with an idea in my mind's eye that later materialized on my easel, such as *Sunday in Central Park*.

In all my traveling, I have found communities of painters and musicians in every city in the world, but in New York these people are everywhere. Let me explain. Most major cities have symphony orchestras that perform, maybe, once every three weeks. In New York they perform three symphonies a week; as a result, opportunities for performers abound. What a joy! There is nothing quite like it anywhere and I'm proud to be a part of the New York painting and musical scene. "If you can make it there, you can make it anywhere," wrote John Kander and Fred Ebb, and I believe this is true.

I learned about my music by being on the scene in New York, and I've also learned about my art. There are wonderful museums almost on my doorstep where I go to meet the masters, to study their techniques, colors, and theme development.

I never tire of capturing the city with my brush. As with the beat of a song, it is always changing. I paint the beat—either flying high or at a standstill. I have no choice; New York City turns up on my canvas.

Above: Childhood days. Right: A happy recording session in the 1940s.

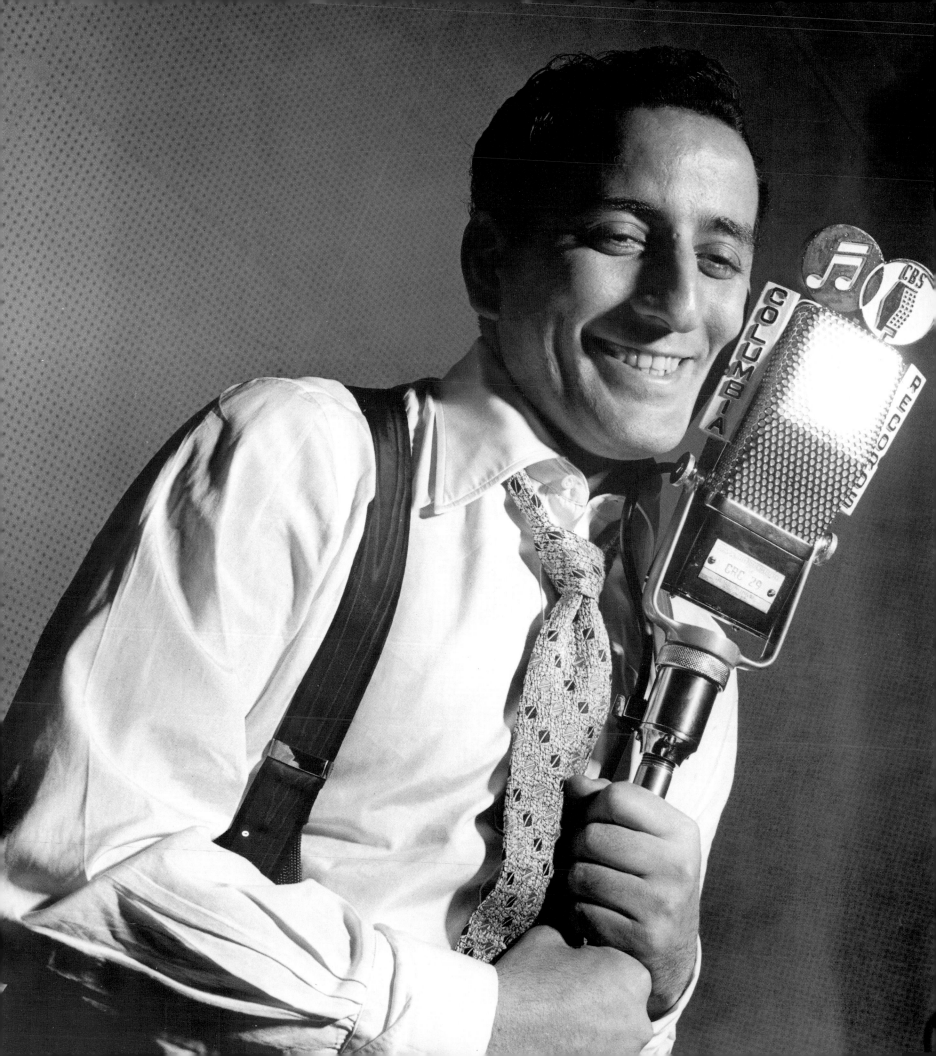

New York Yellow Cab No. 1
oil on canvas
30 x 24 inches

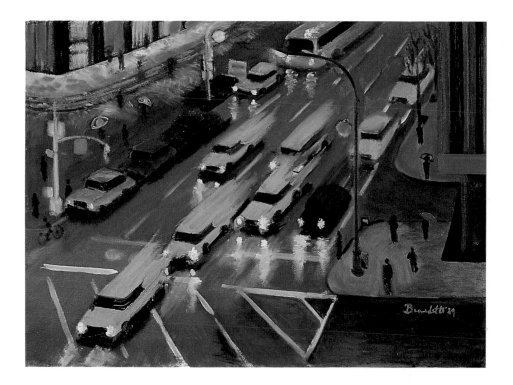

Yellow Cab No. 7
oil on canvas
20 x 24 inches

New York Rainy Night
oil on canvas
20 x 16 inches

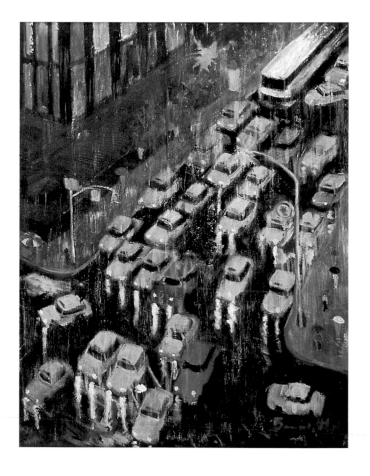

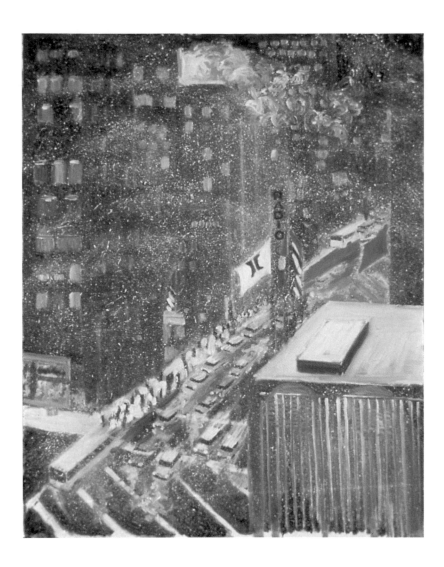

New York Snowstorm
oil on canvas
30 x 24 inches

Avenue of the Americas
oil on canvas
30 x 24 inches

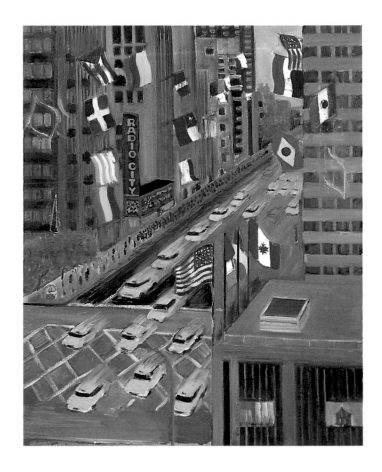

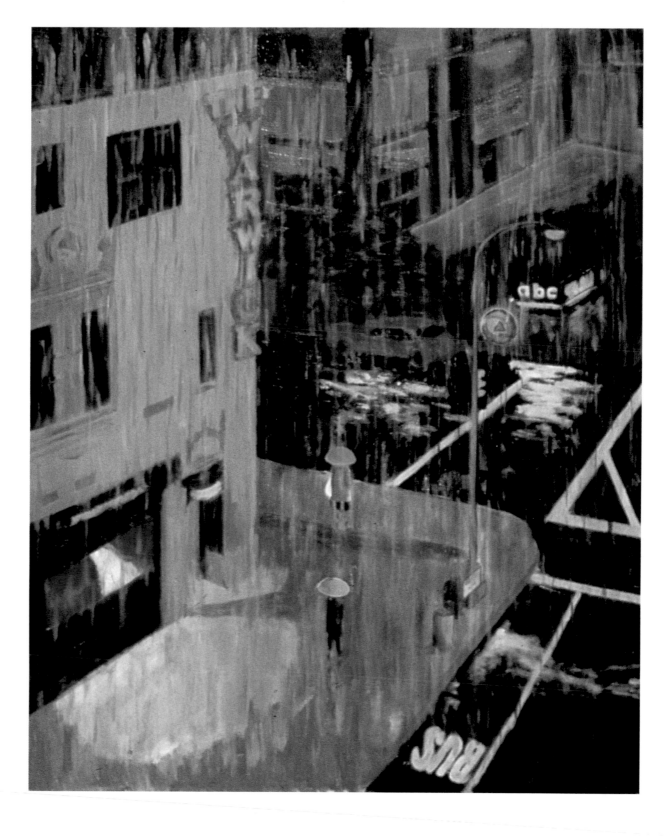

New York Rainy Night
oil on canvas
30 x 24 inches

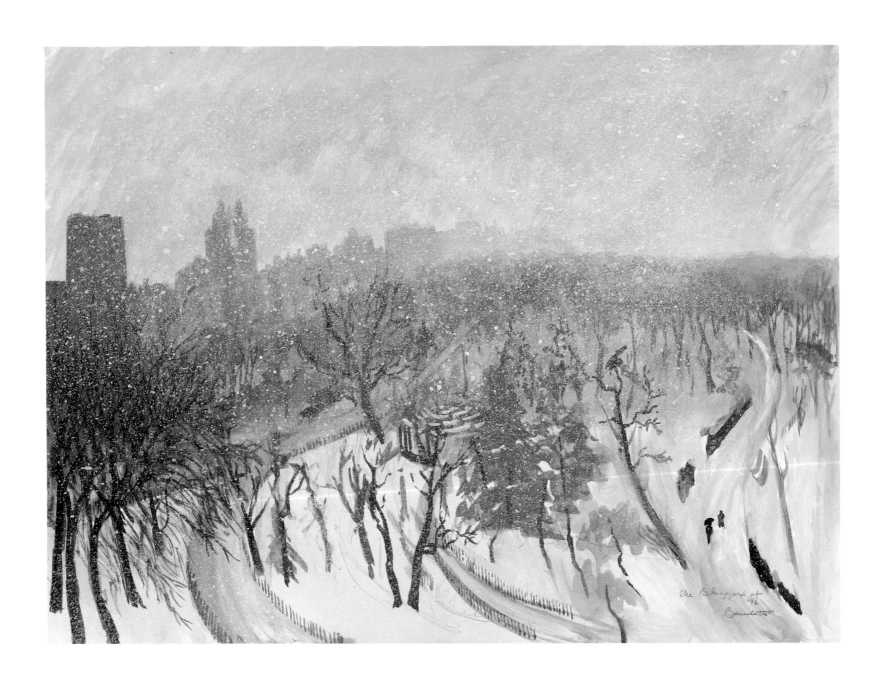

The Blizzard of '96
watercolor
18 x 24 inches

Workers 47 Stories High
oil on canvas
30 x 40 inches

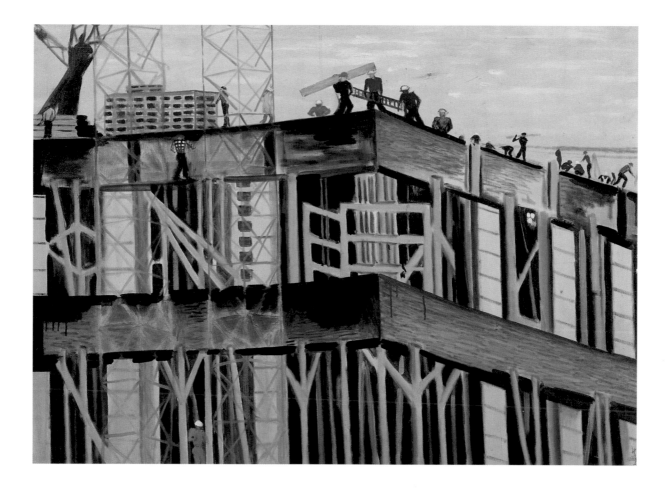

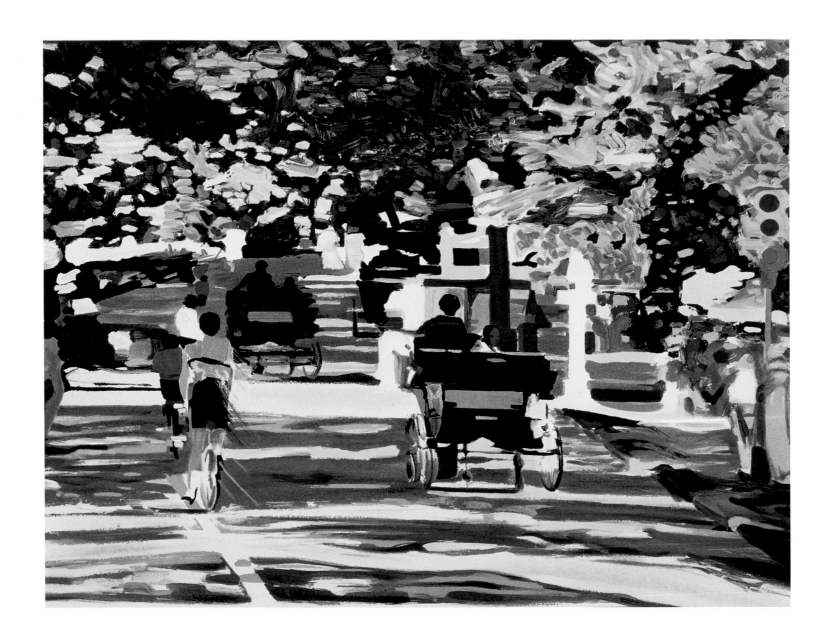

Sunday in Central Park
oil on canvas
30 x 40 inches

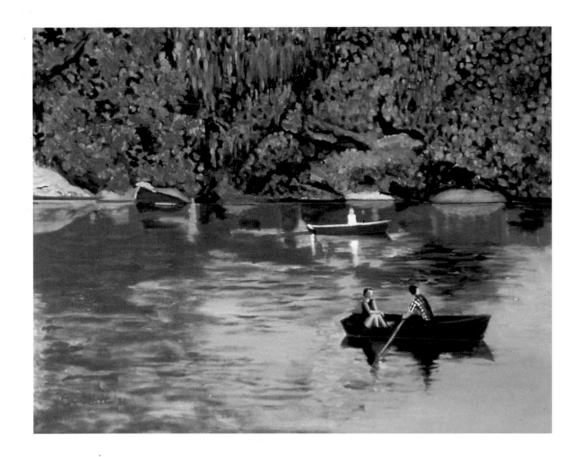

Central Park No. 1
oil on canvas
30 x 40 inches

Brotherhood (U.N. 50th Anniversary)
oil on canvas
30 x 40 inches

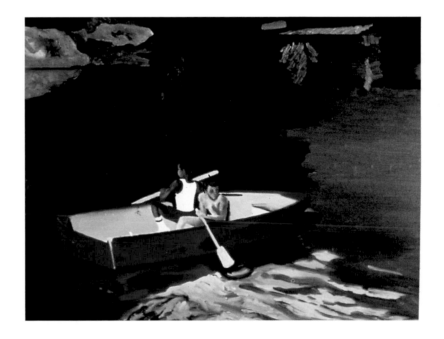

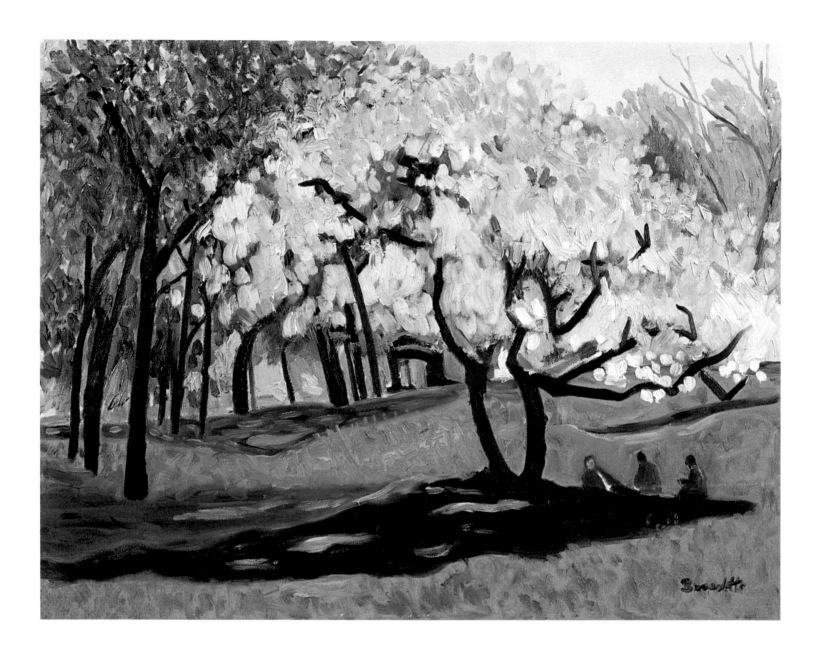

Central Park No. 8
oil on canvas
22 x 28 inches

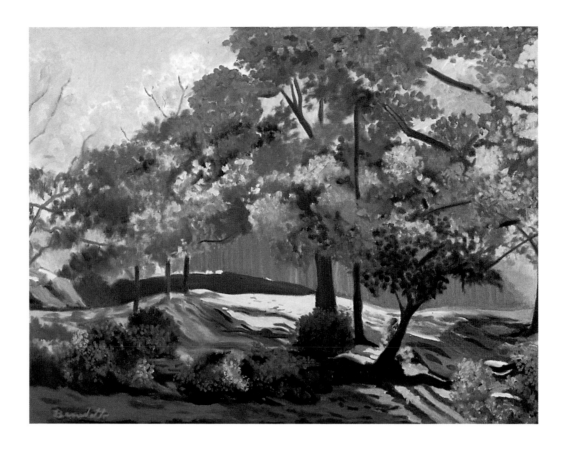

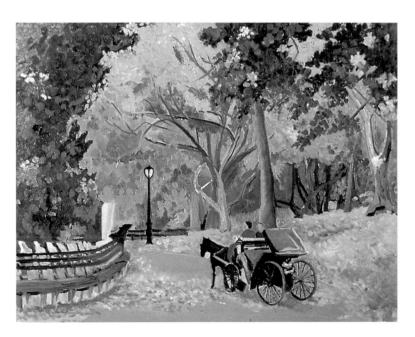

Central Park 1991
oil on canvas
22 x 28 inches

Autumn in New York
oil on canvas
22 x 28 inches

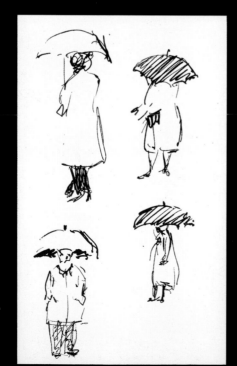

ALEXANDER H.
COHEN

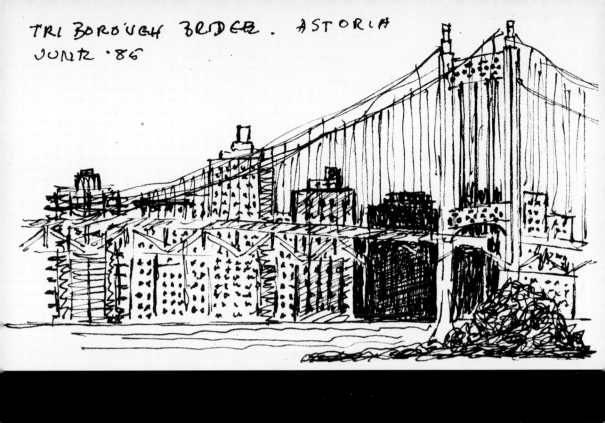

TRI BOROUGH BRIDGE . ASTORIA
JUNE '86

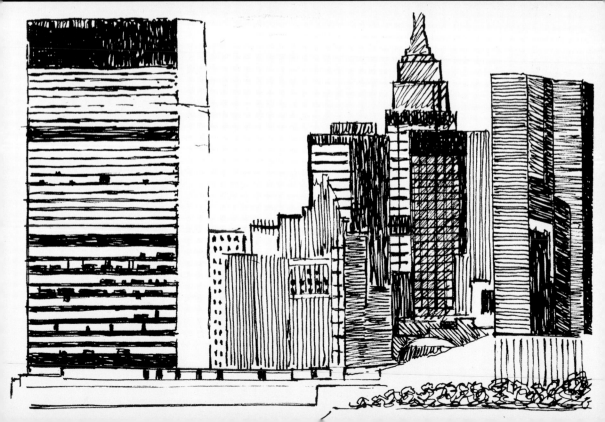

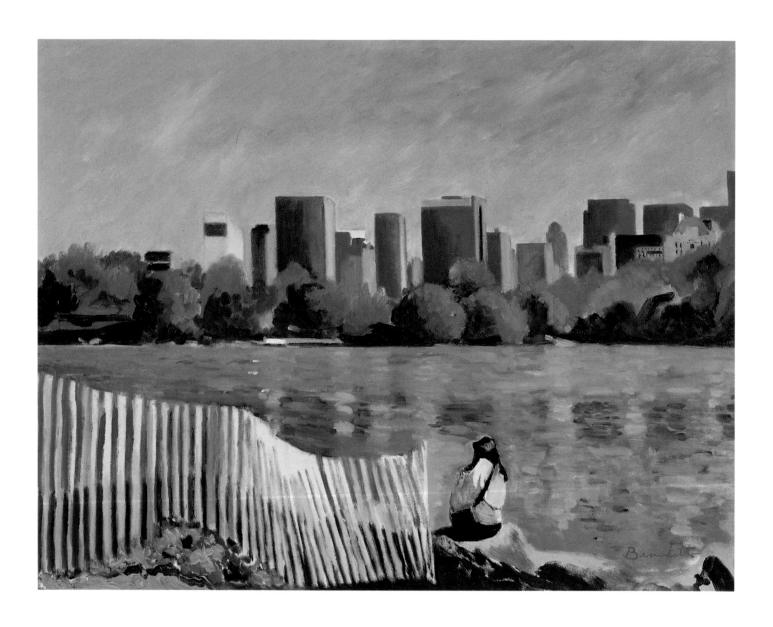

Central Park Dreaming
oil on canvas
20 x 24 inches

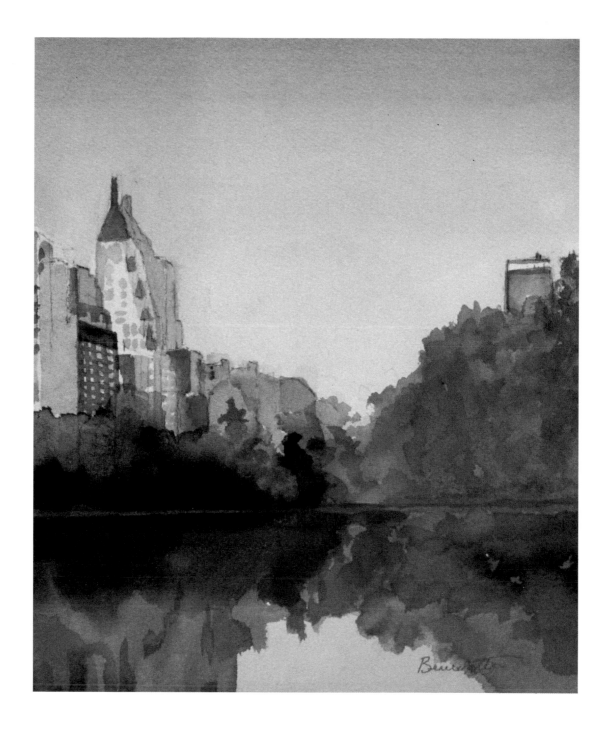

Central Park Pond
watercolor
19 x 11 inches

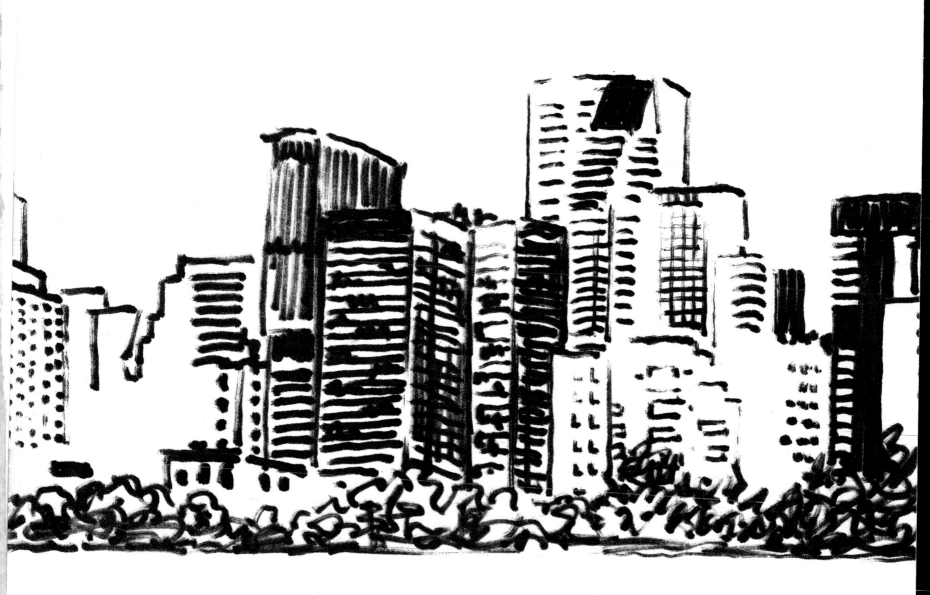

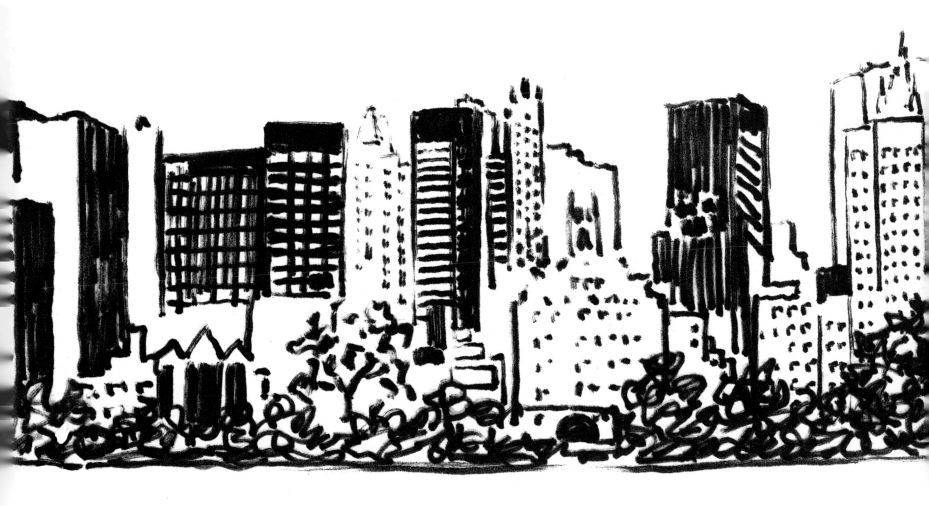

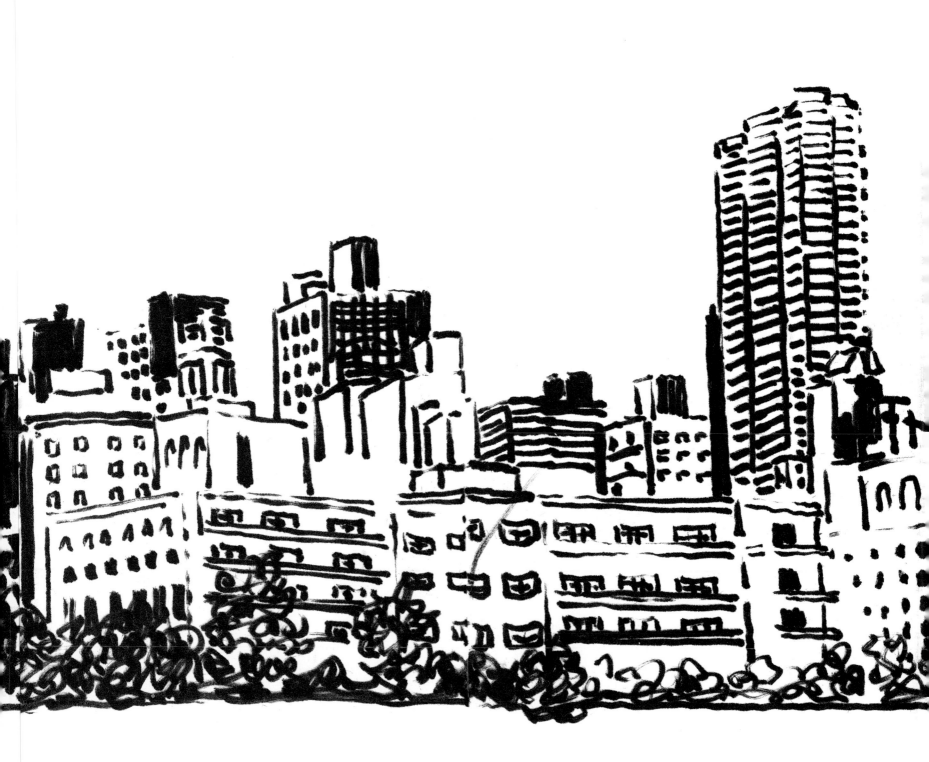

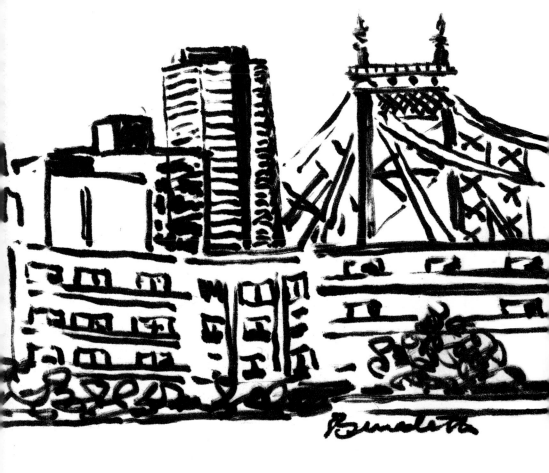

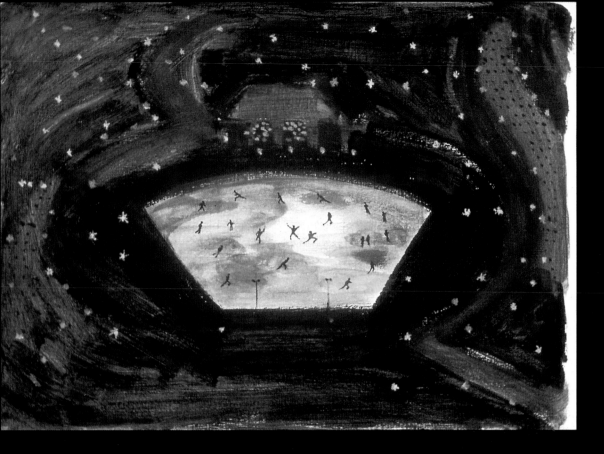

Wollman Rink, Central Park at Night
oil on canvas
12 x 16 inches

Central Park, Fall
oil on canvas
12 x 16 inches

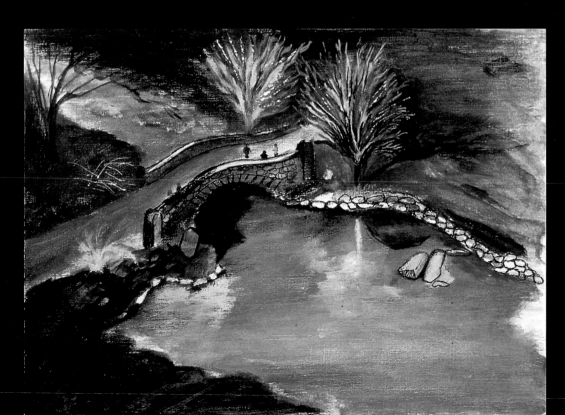

Around the World

*A*round the World in 80 Days, directed by the late Mike Todd, is one of the most spectacular travel movies ever. With all due respect to Jules Verne and Mike Todd, we do not travel by hot air balloon, but my trio and I have made it around the world in less time on many a concert tour. Not long ago, we performed in New York City, then played in Hawaii, Guam, Thailand, Singapore, and finished with a stop in London for a show at the Royal Festival Hall before returning to New York— all within seventeen days.

To me the best education a person can get is to travel. For the past forty years I've been privileged to sing in every major city, from New York to Tokyo, Los Angeles to Sydney. You name it—I've been there. Naturally, wherever I go, my paints, brushes, and pencils go too.

Greeting old friends and meeting new ones all over the world is one of my life's greatest pleasures. Each city, whether big or small, has an art gallery for me to visit. I look and learn, marvel at the creativity of my fellow artists, and I sketch and paint. There is no limit to the unpredictable and varying landscapes, the vibrant colors, interesting faces, and myriad other subjects waiting to be

Left: A charming welcome home after a tour.

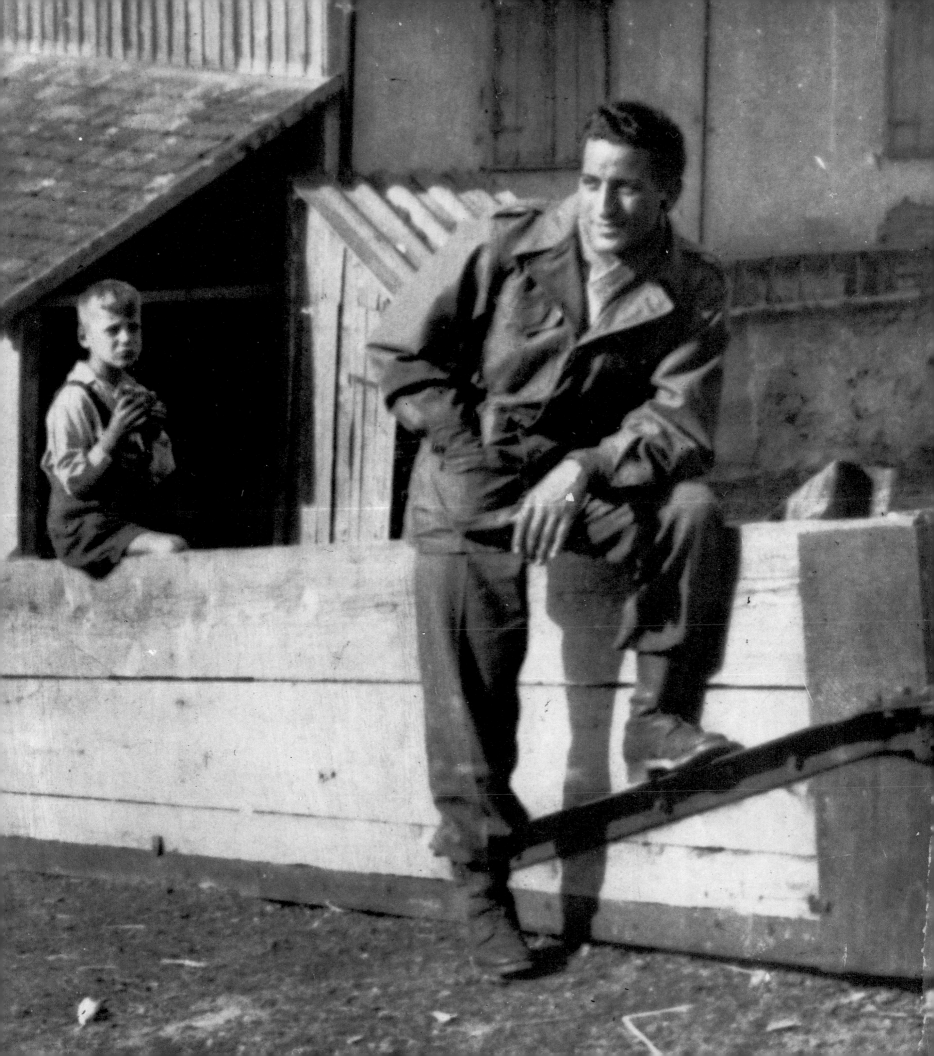

put on my canvas. By my constant traveling I have gained a unique perspective of the world.

When I go to Japan to perform in Tokyo, I also make a point of visiting the ancient and mysterious city of Kyoto. Among its many fascinating buildings, there is a one-thousand-year-old temple in the middle of a lake. It draws me like a magnet, and I have often sketched it. The painting *Golden Pavilion* is the result of those visits.

As you can well imagine, one of my all-time favorite cities in which to sing and paint is San Francisco. It is so picturesque that I will never run out of sites to set on canvas, however often I go back. I've painted "little cable cars, climbing halfway to the stars," the Golden Gate Bridge, and Coit Tower, the famous land-mark that commemorates the service of the firefighters in this great city. San Francisco has embraced me for many years and I feel I am able to return that love through my paintings of the City by the Bay.

There are many other points of interest all over the world that for me have the label "must paint" attached to them. In Sydney, Australia, I have sketched the Opera House. This unique architectural structure by Jørn Utzon offers endless opportunities and challenges for an artist. One of my visits to Rio de Janeiro happened to coincide with the height of the Brazilian World Cup fever. The whole city was a hive of excitement and I think I have been able to convey that in my painting of the colorful hillside with its crawling and sprawling houses. Without any postcards or the aid of a camera, I have my paintings and sketches to remind me of all the places I've visited throughout my long career. They are my travel diary, to which I add pages wherever I go.

Left: In Bad Schwalbach, Germany, 1946. Above: Entertaining fellow soldiers.

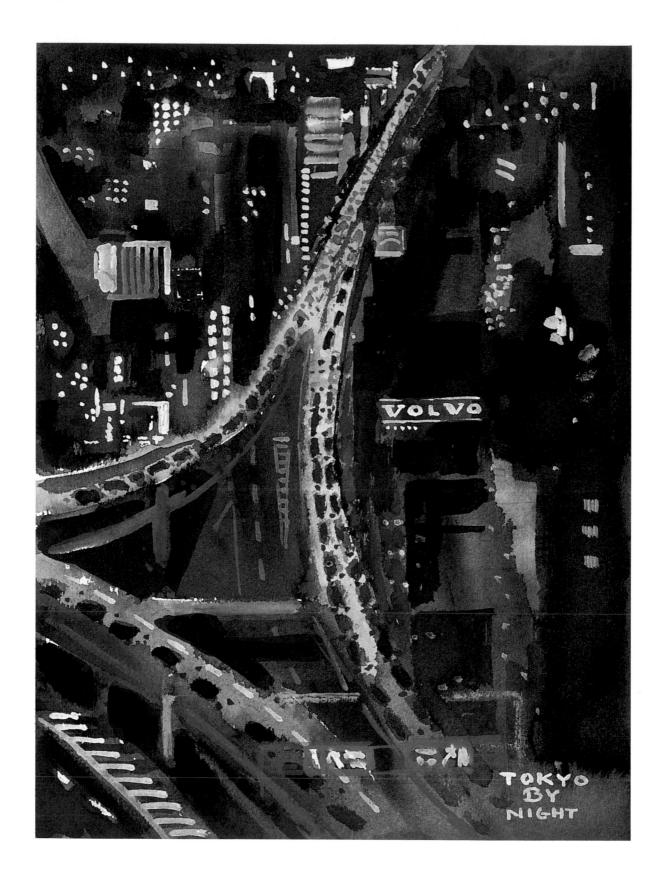

Tokyo by Night
watercolor
15 x 11 inches

TOKYO GARDEN SCROLL

'90

Benedetto

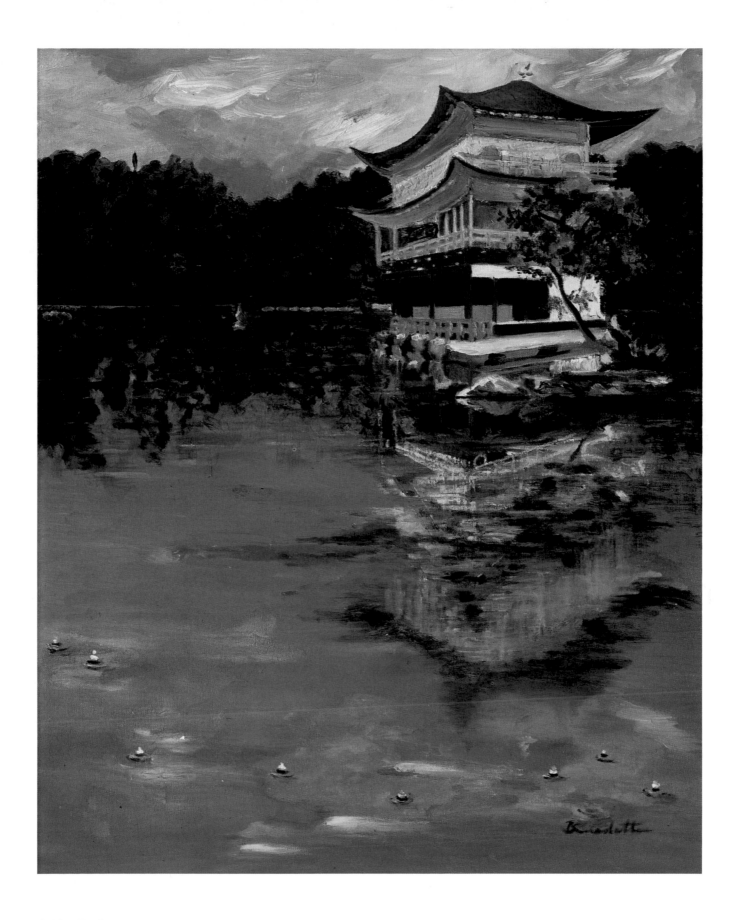

Golden Pavilion
oil on canvas
30 x 24 inches

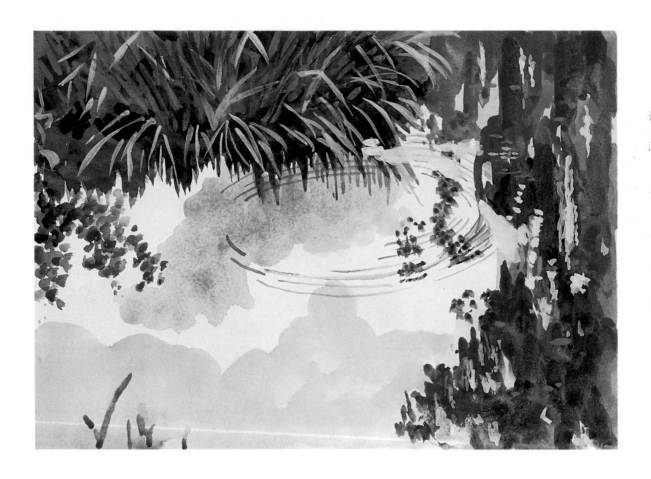

**Reflection on Pond,
Nova Scotia**
watercolor
10 x 14 inches

Bangkok
watercolor
14 x 20 inches

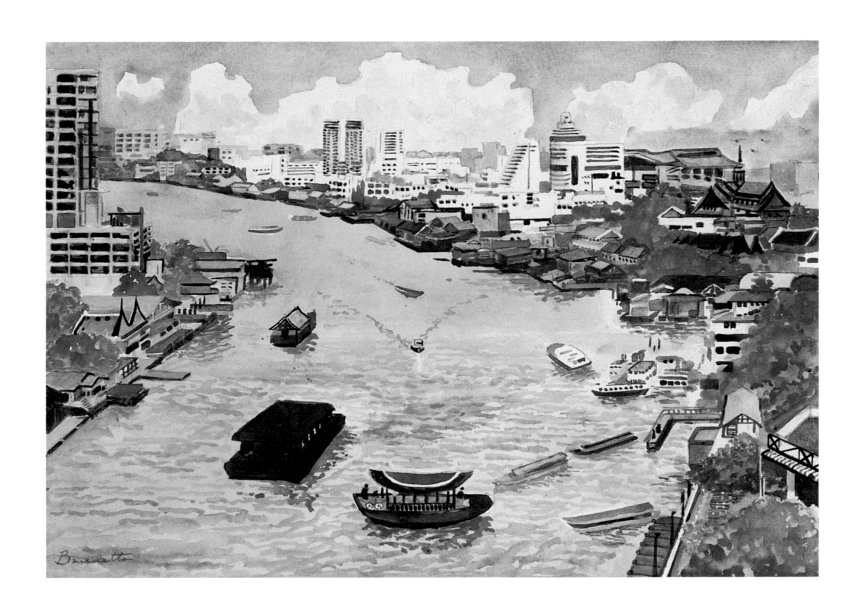

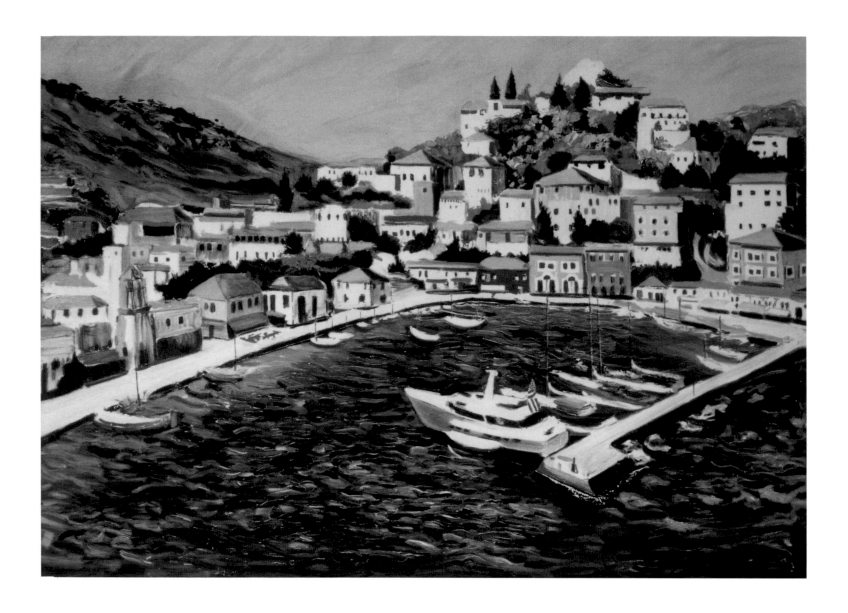

Greek Port—Crete
oil on canvas
30 x 40 inches

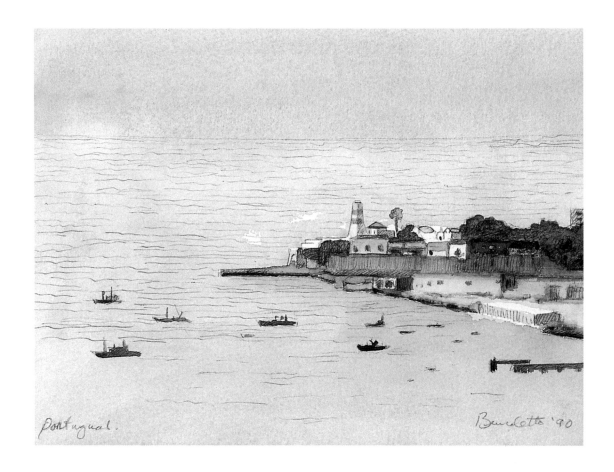

Portugal
watercolor
9 x 12 inches

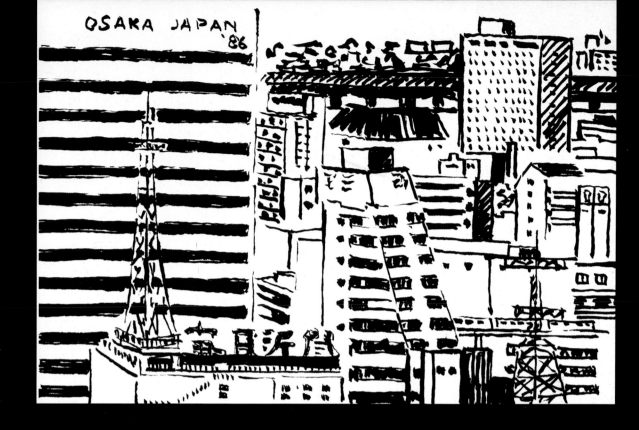

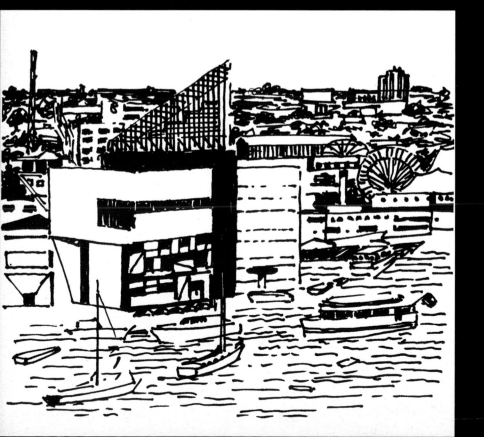

Urban sights

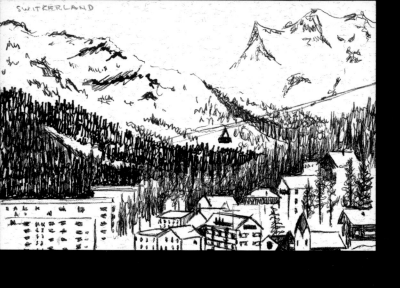

SWITKERLAND

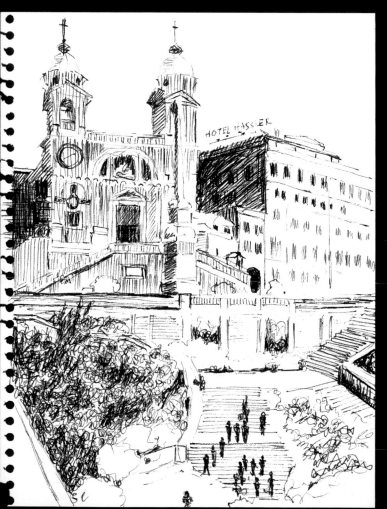

HOTEL HASSLER

European views

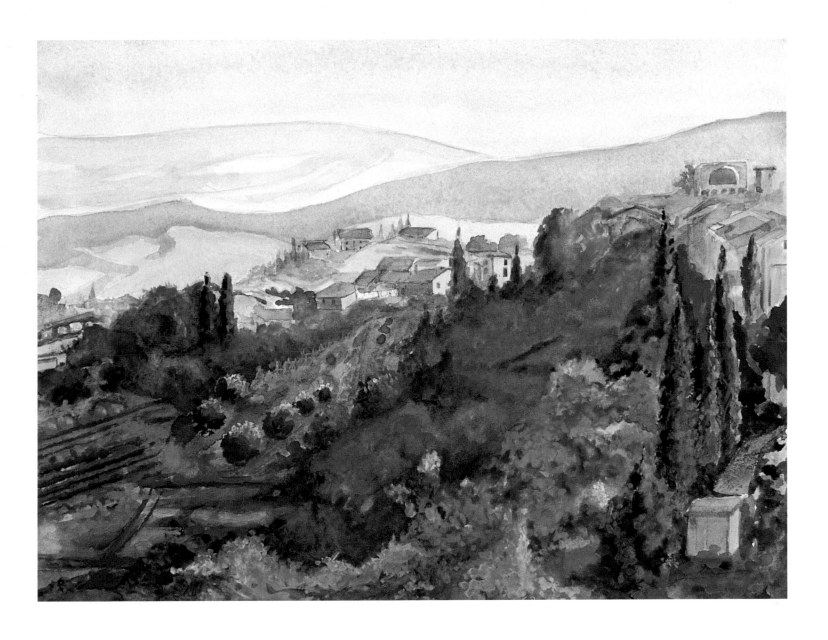

Florence
watercolor
12 x 16 inches

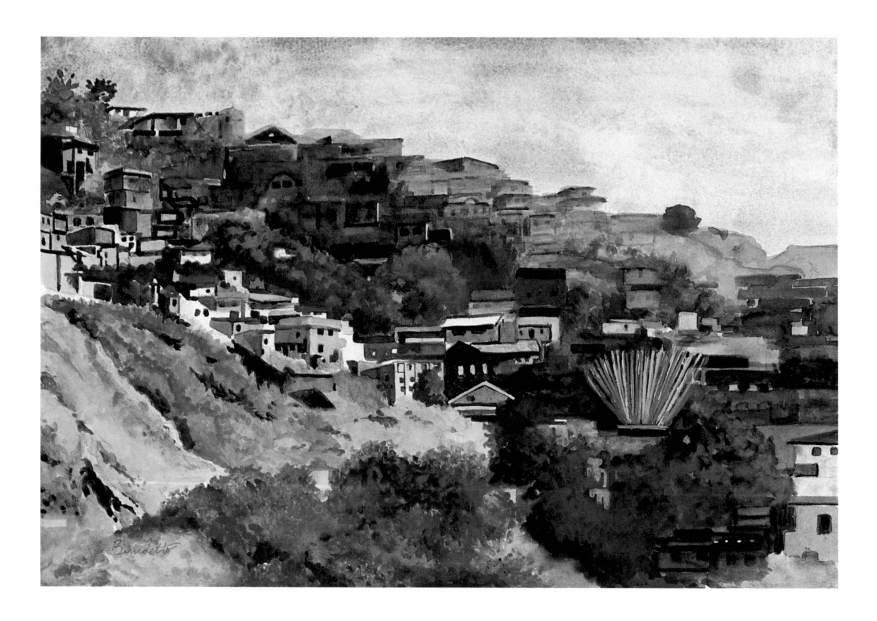

Football Season in Rio
watercolor
14 x 20 inches

Rio de Janeiro
watercolor
18 x 15 inches

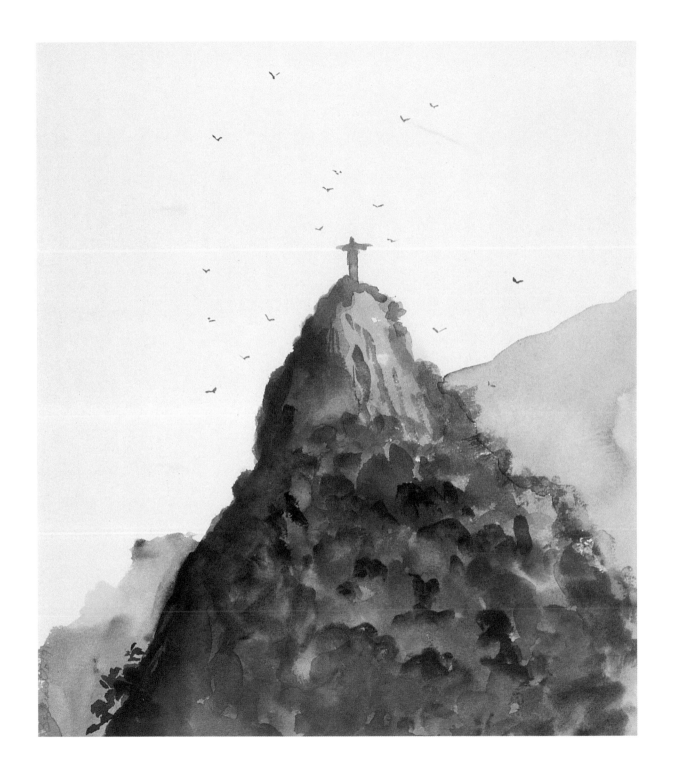

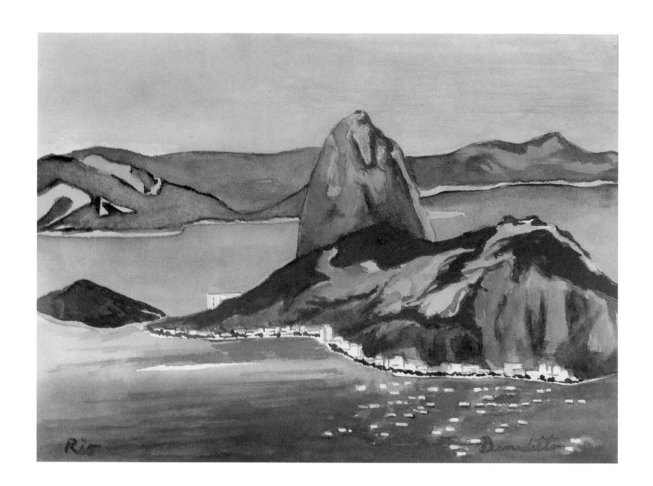

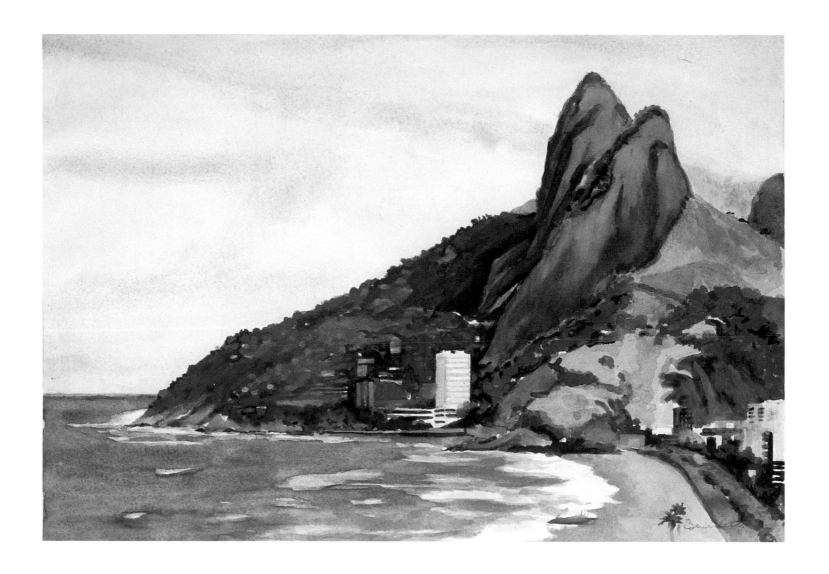

Rio
watercolor
9.5 x 12.5 inches

Mountain of Two Brothers, Rio
watercolor
14 x 20 inches

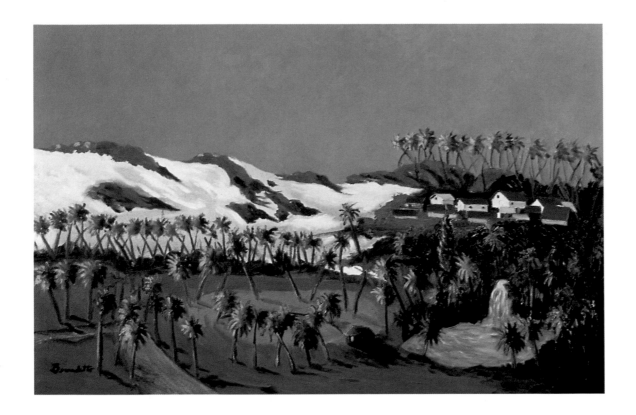

Bahia, Brazil, White Sand Beach
oil on canvas
24 x 36 inches

Bahia
oil on canvas
14 x 20 inches

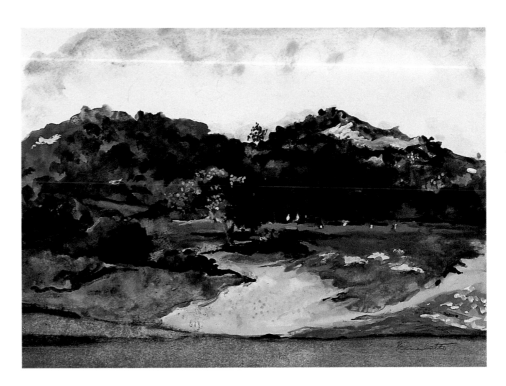

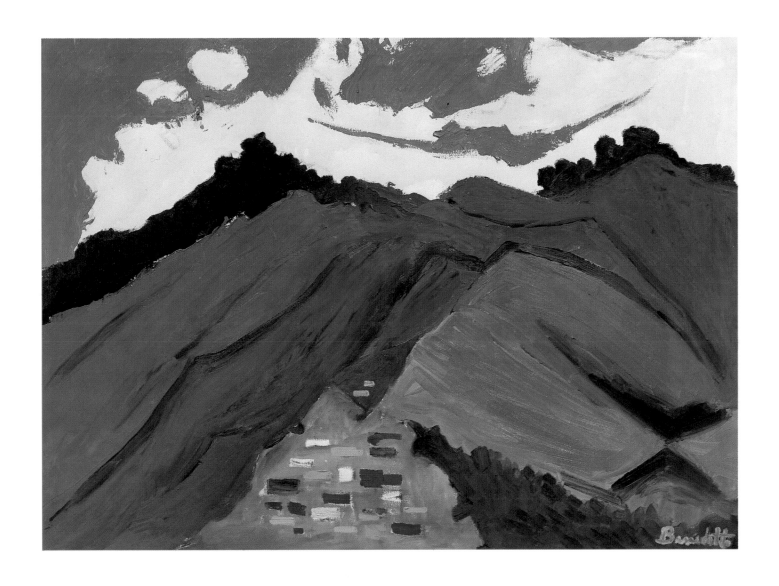

Venezuela
oil on canvas
36 x 48 inches

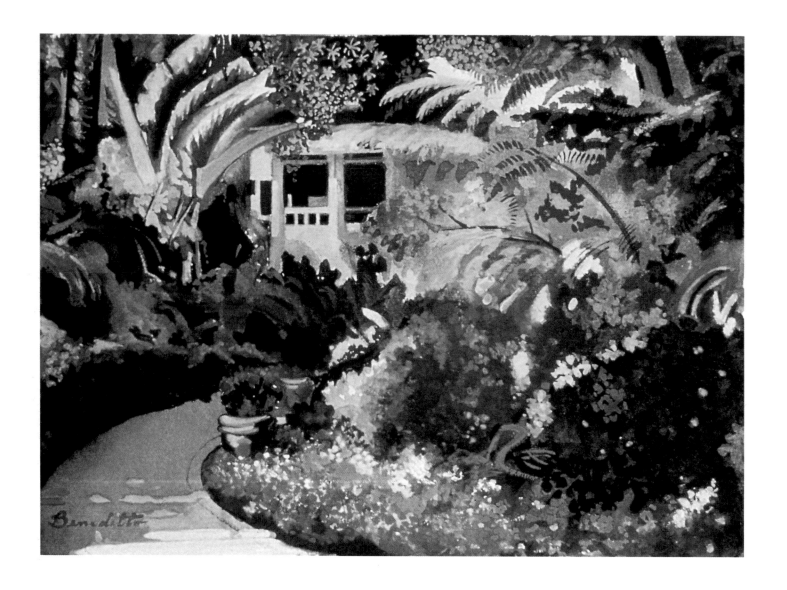

Beverly Hills Bungalow
watercolor
9 x 12 inches

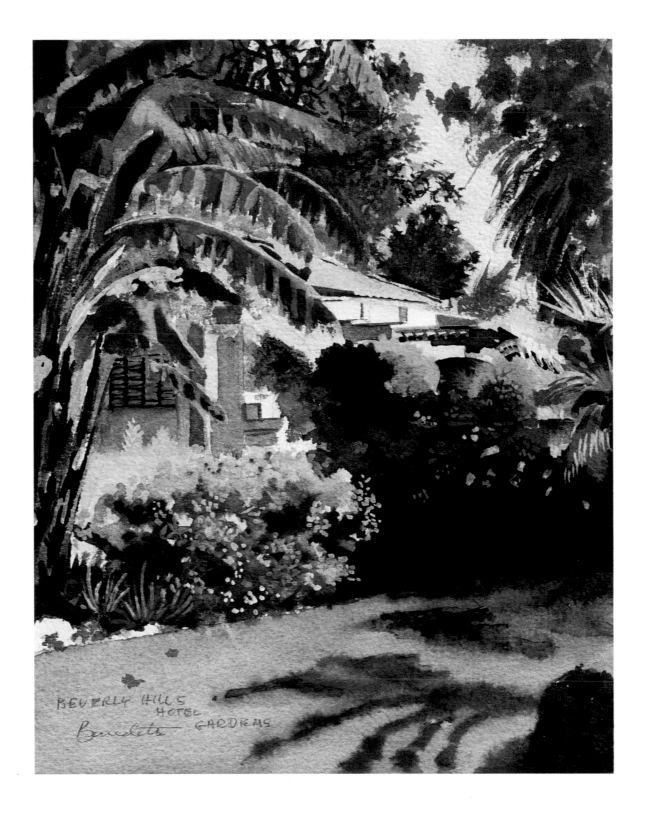

Beverly Hills Hotel
watercolor
11 x 8.5 inches

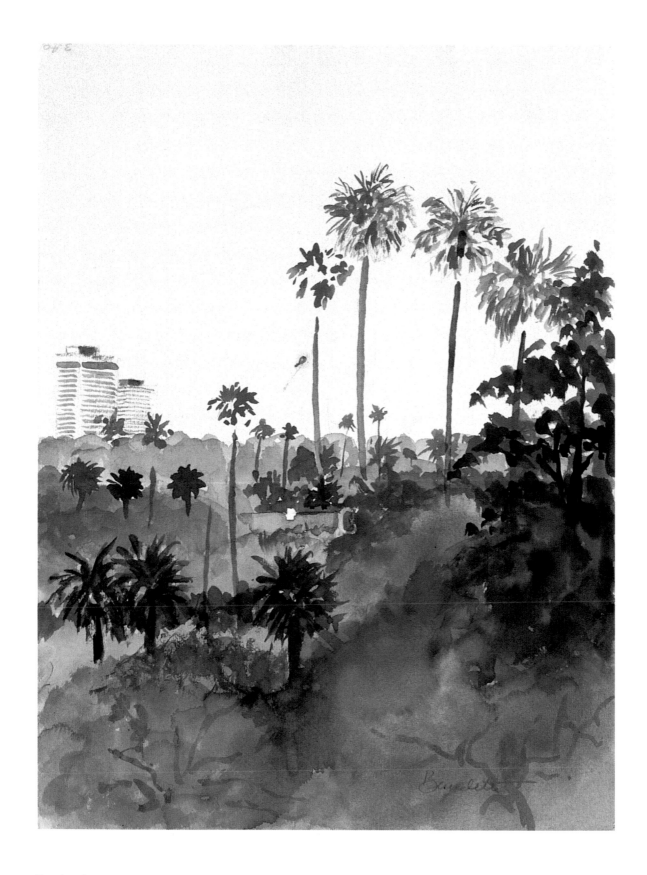

Los Angeles
watercolor
15 x 11 inches

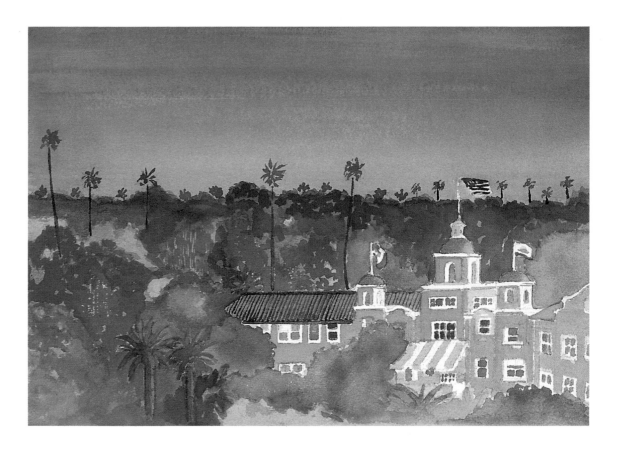

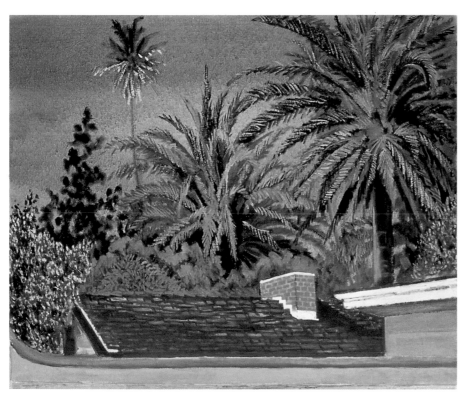

Beverly Hills Hotel
watercolor
11 x 15 inches

Beverly Hills Rooftop
oil on canvas
20 x 24 inches

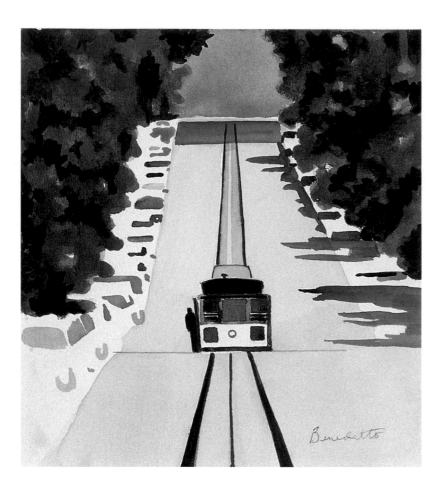

San Francisco Cable Car
watercolor
11 x 10 inches

San Francisco Street Scene No. 1
watercolor
19 x 20 inches

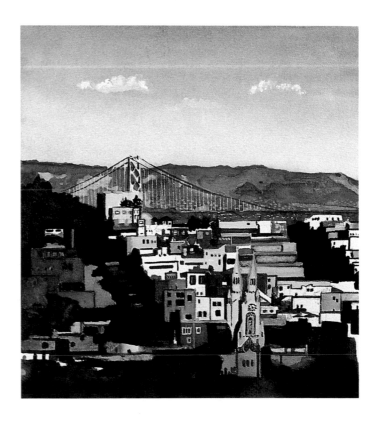

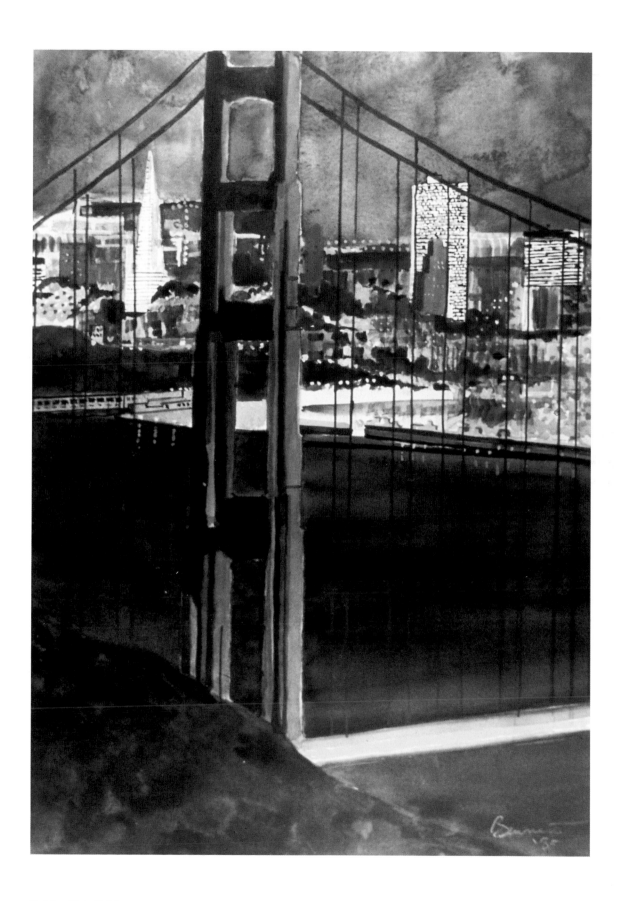

Golden Gate Bridge
watercolor
21 x 14 inches

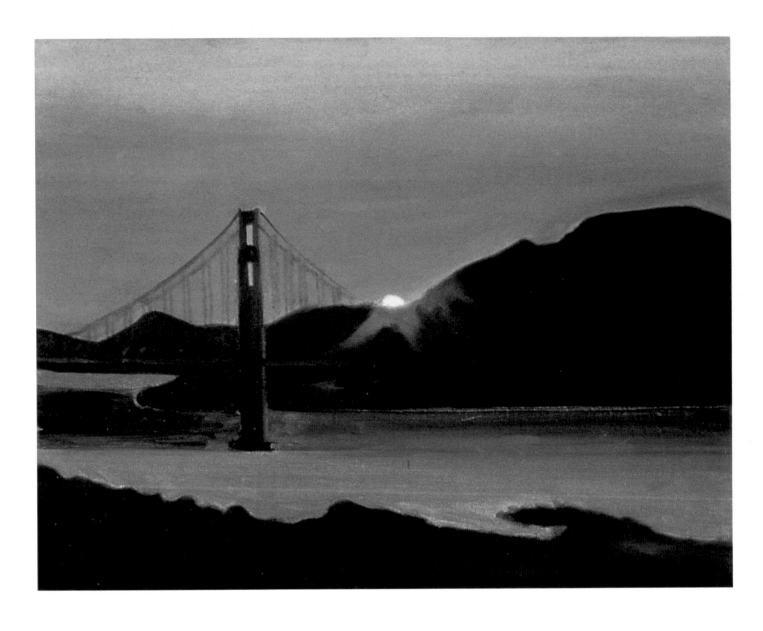

Golden Gate Bridge
watercolor

S
A
N

F
R
A
N
C
I
S
C
O

S
C
R
O
L
L

'90

Benedetto

San Francisco Postcards
watercolor
4 x 5.75 inches

COIT TOWER.

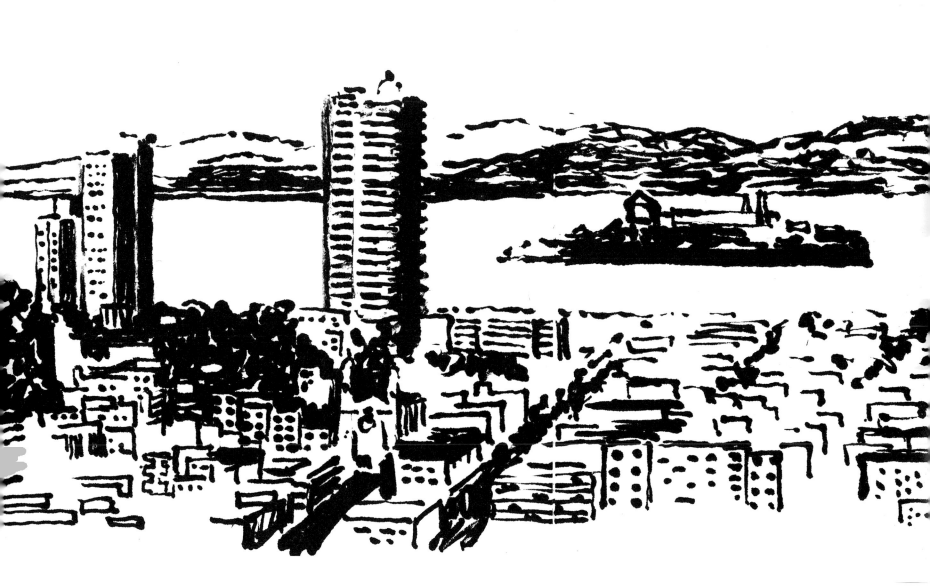

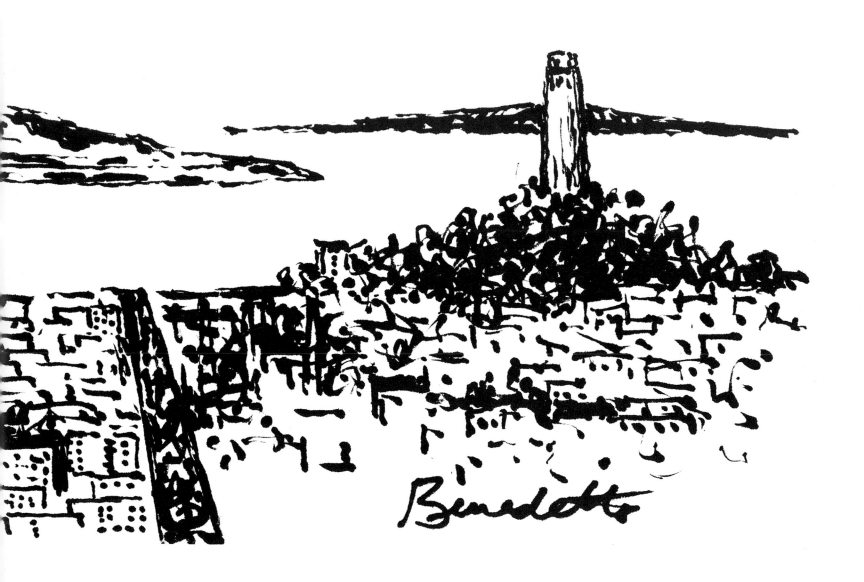

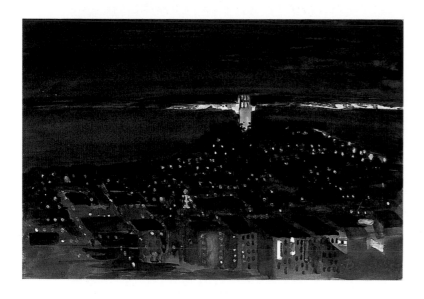

Coit Tower at Night
watercolor
14 x 20 inches

Coit Tower, Evening
gouache
12 x 16 inches

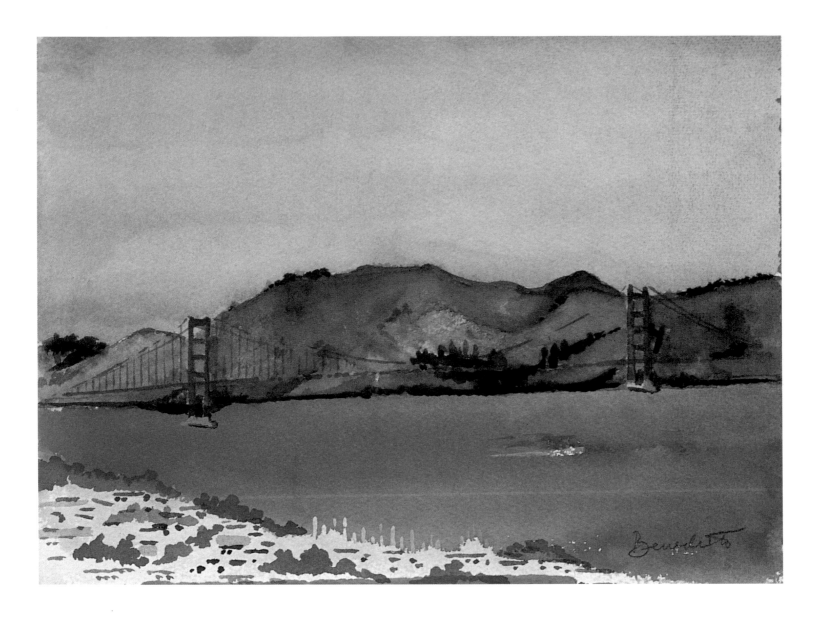

Golden Gate Bridge
watercolor
9 x 12 inches

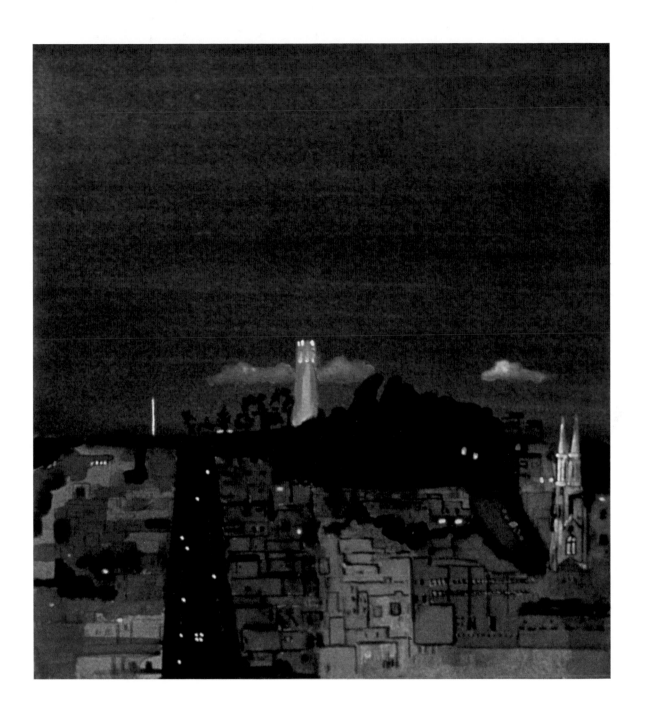

San Francisco at Night
watercolor
10.5 x 9.5 inches

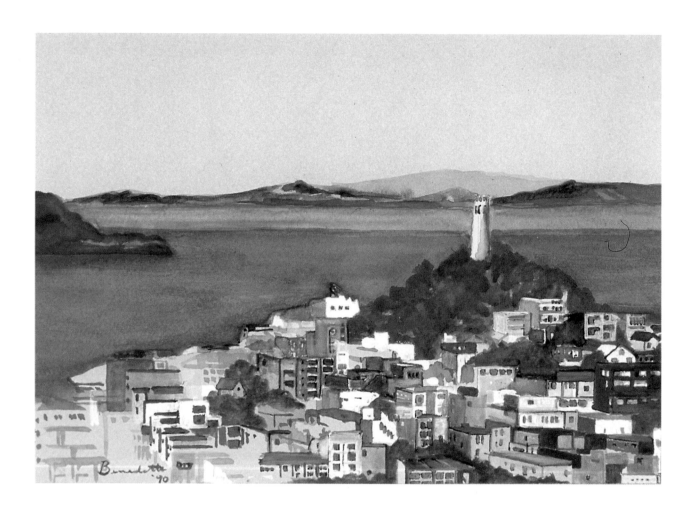

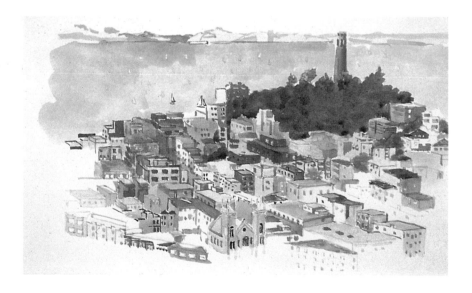

Coit Tower by Day
watercolor
10 x 14 inches

San Francisco
gouache
12 x 16 inches

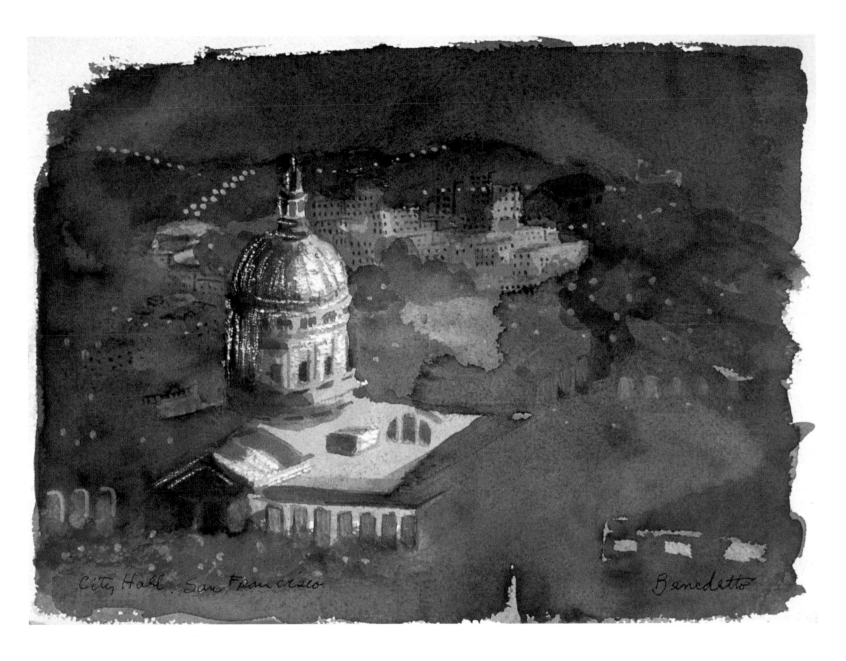

City Hall, San Francisco Benedetto

San Francisco City Hall
watercolor
9.5 x 12.5 inches

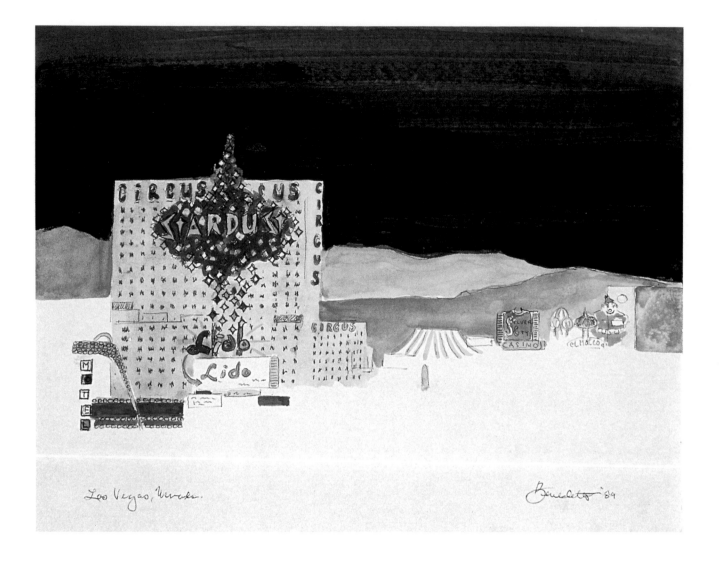

Las Vegas, Nevada.

Benedetto '89

Las Vegas—Daytime
watercolor
9.5 x 12 inches

Stardust
watercolor and gouache
11 x 15 inches

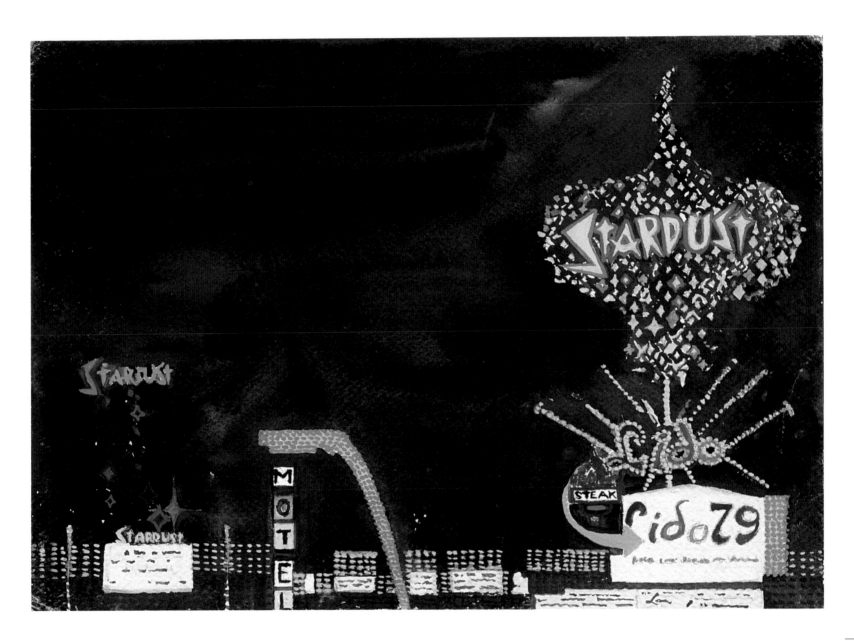

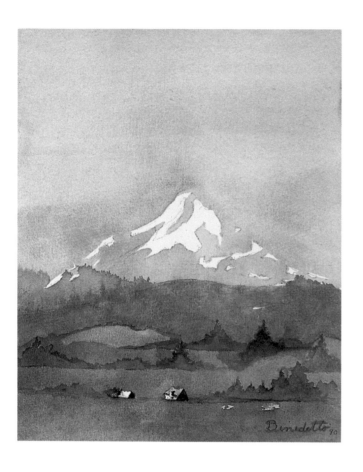

Mount Hood
watercolor
20 x 14.25 inches

Pebble Beach
watercolor and gouache
11 x 15 inches

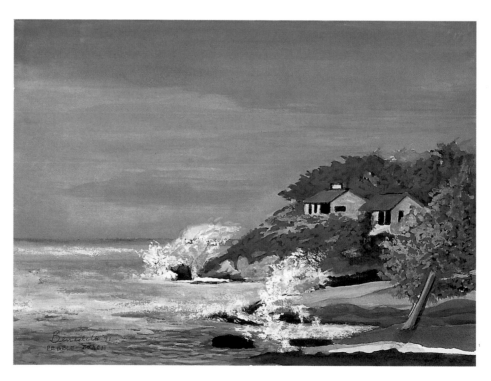

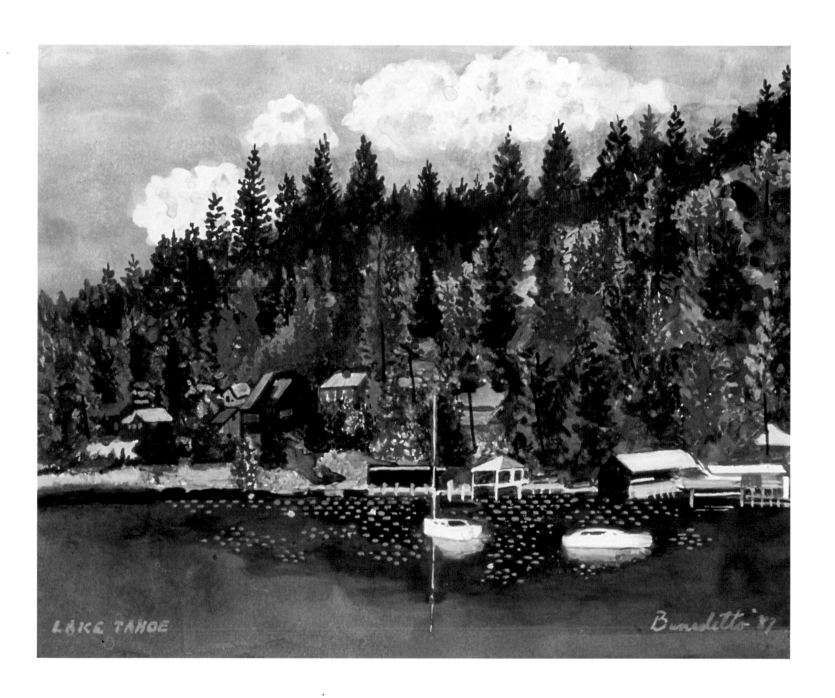

Lake Tahoe
watercolor
11 x 14 inches

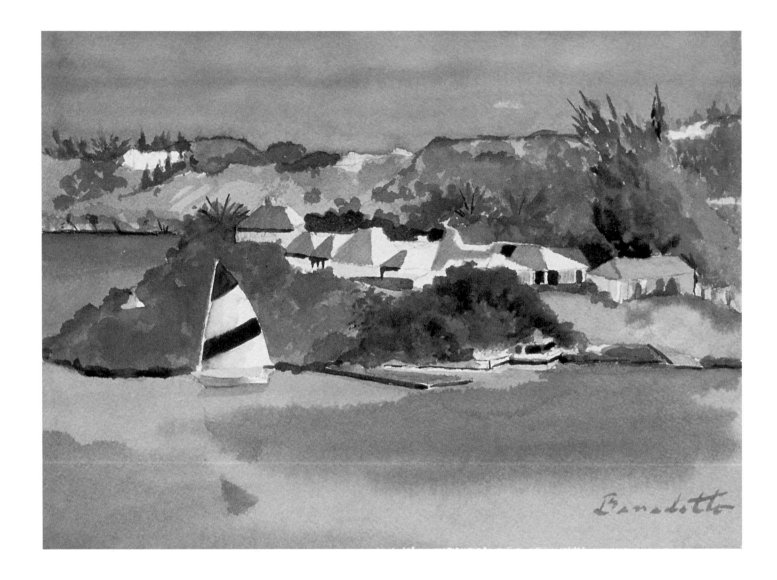

Bermuda
watercolor
9 x 12 inches

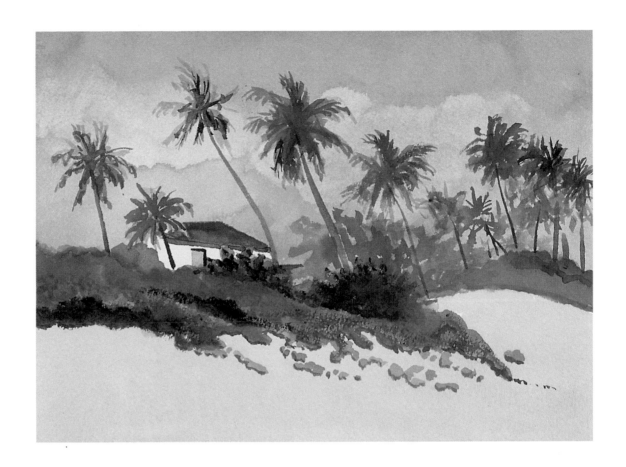

Bahia
watercolor
7 x 9.5 inches

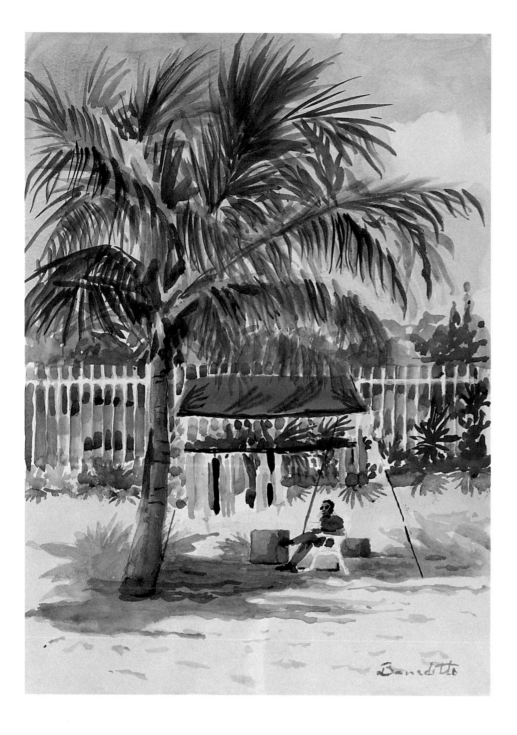

Puerto Rico
watercolor
20 x 14 inches

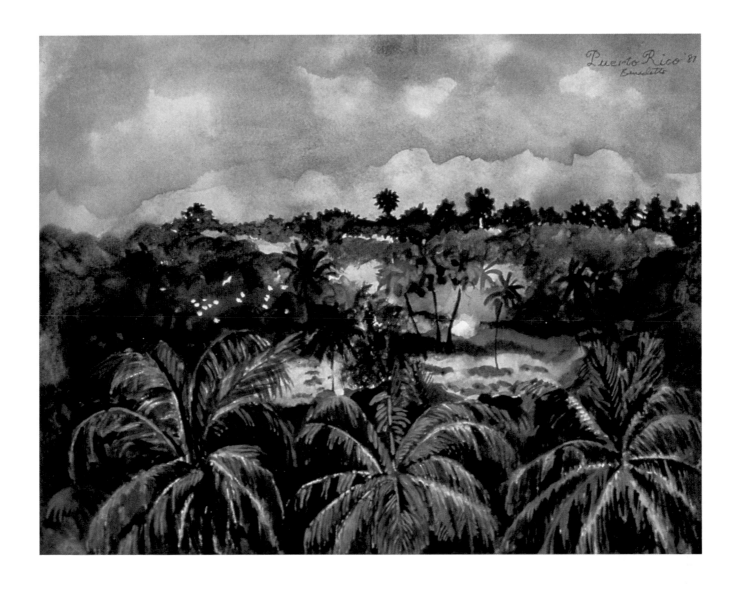

Puerto Rico
watercolor
11 x 15 inches

Wolftrap
watercolor and gouache
9 x 12 inches

Ravinia Stars
oil on canvas

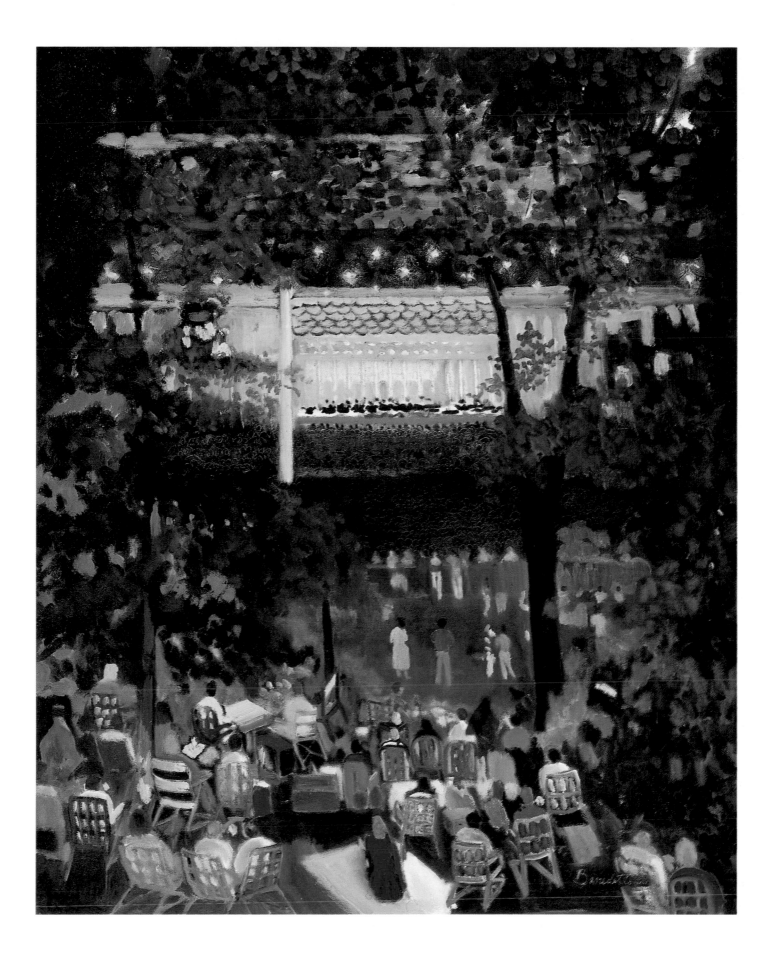

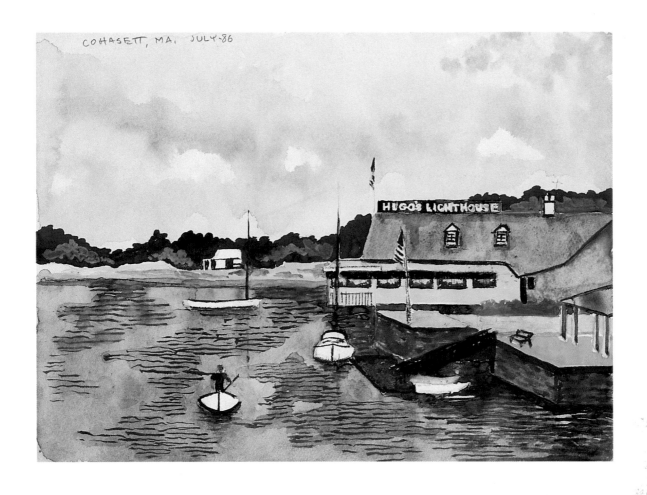

Hyannis, Massachusetts
watercolor
9 x 12 inches

San Diego Bay
watercolor
11 x 15 inches

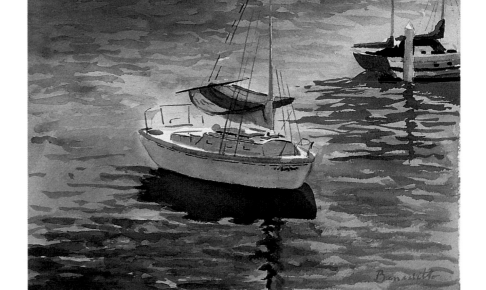

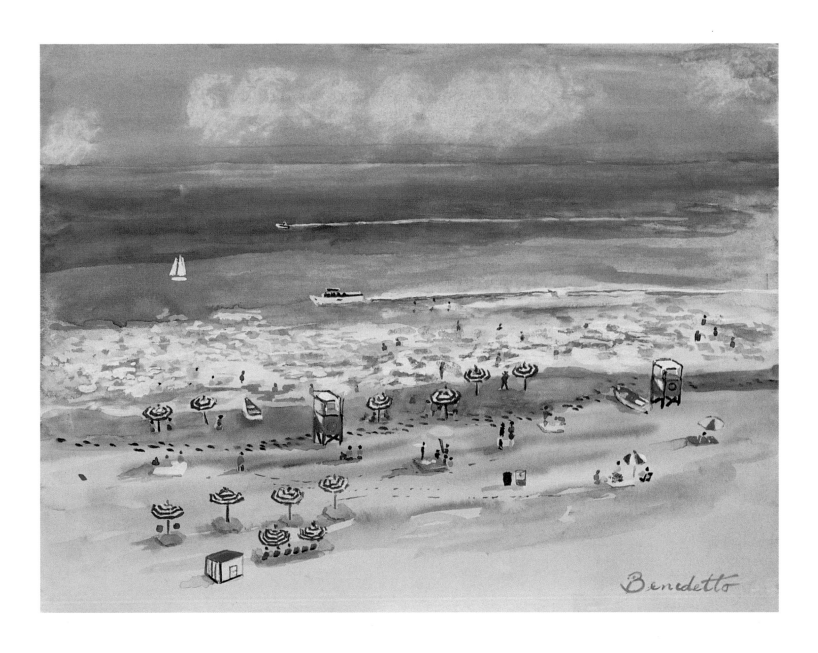

Atlantic City
watercolor
11 x 14 inches

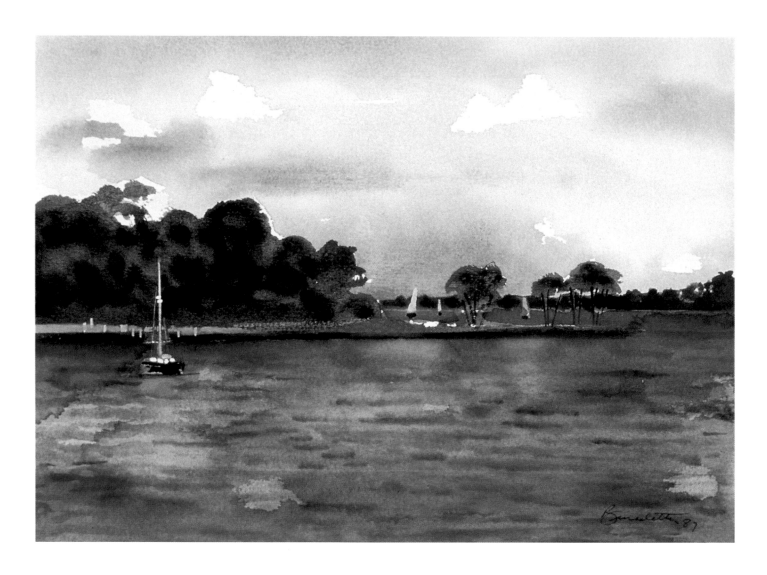

Cape Cod
watercolor
11 x 15 inches

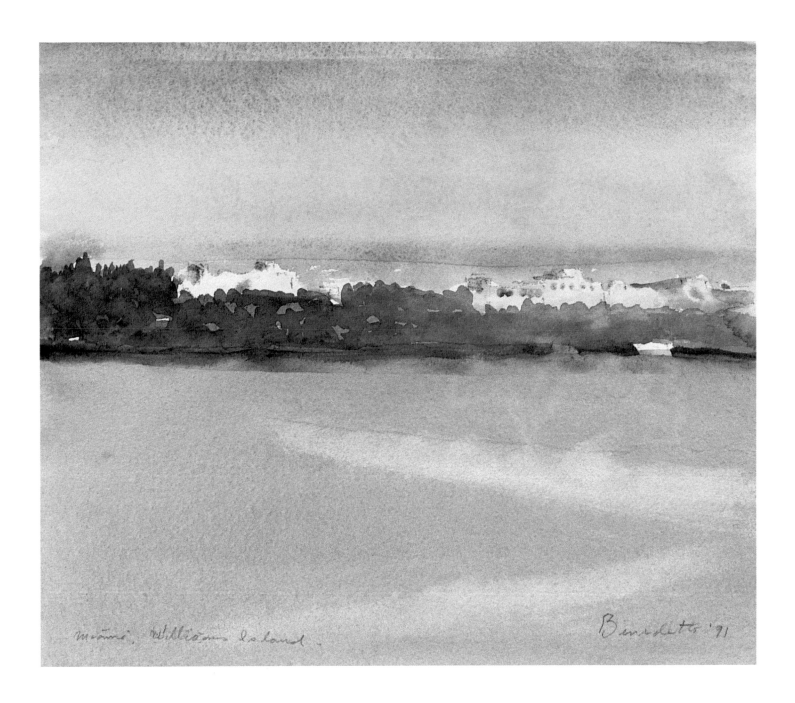

Williams Island
watercolor
10 x 11.5 inches

Boston
oil on canvas
12 x 16 inches

Louisville, Kentucky
watercolor
12 x 16 inches

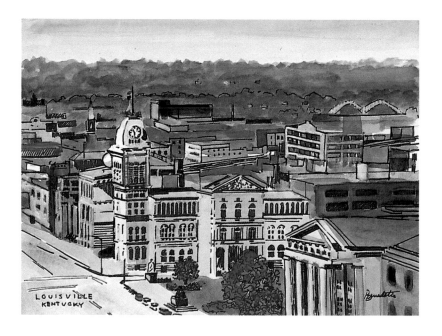

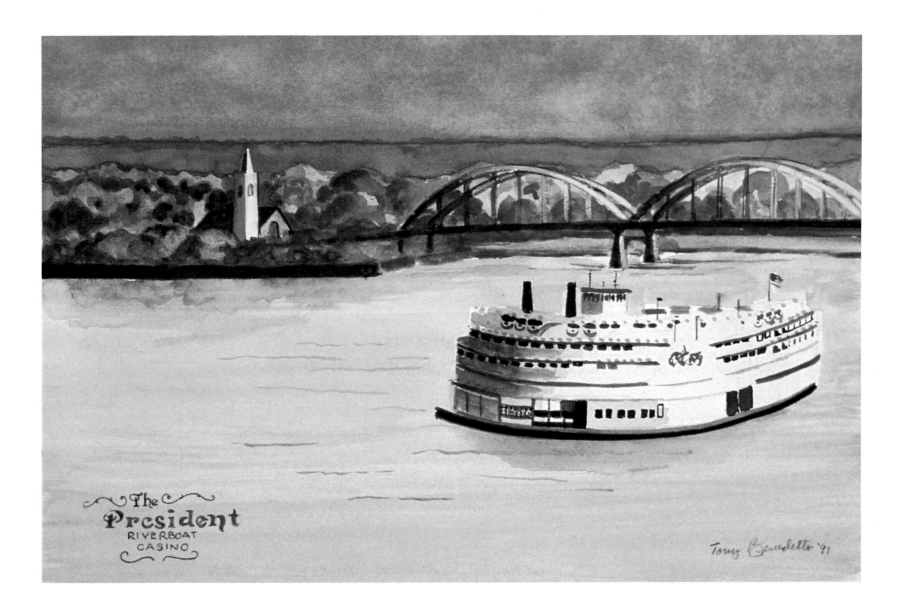

The President Riverboat Casino
watercolor
11 x 15 inches

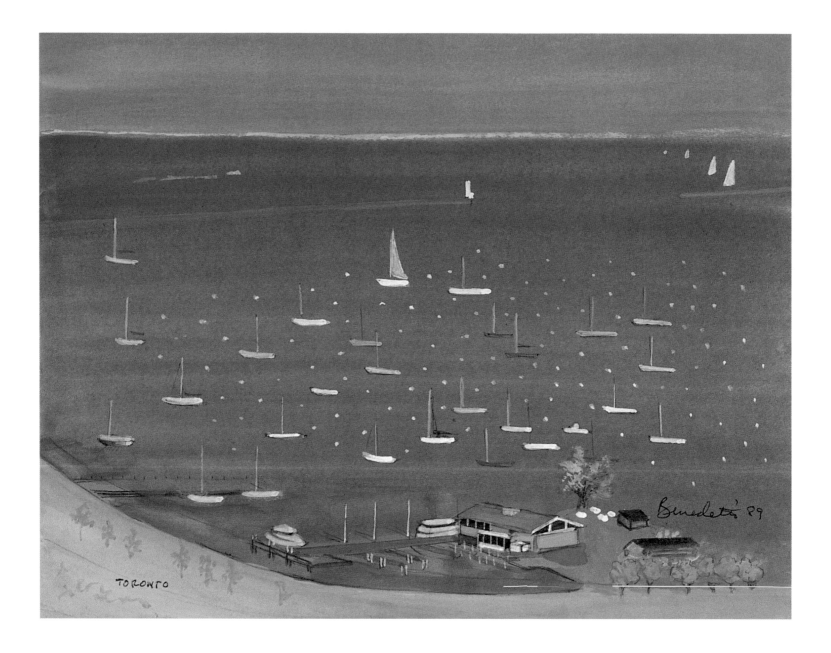

TORONTO

Benedetto '89

Toronto Bay
watercolor
9.5 x 12 inches

Lake Michigan
watercolor
14 x 10 inches

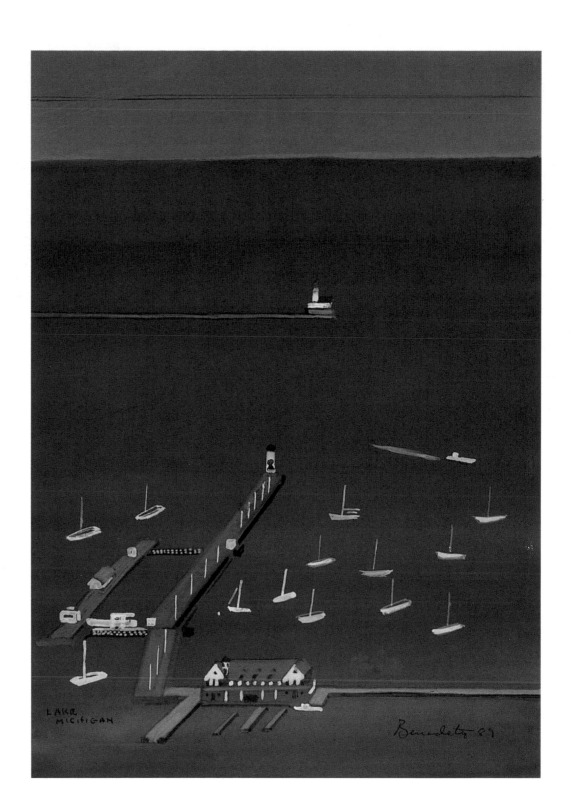

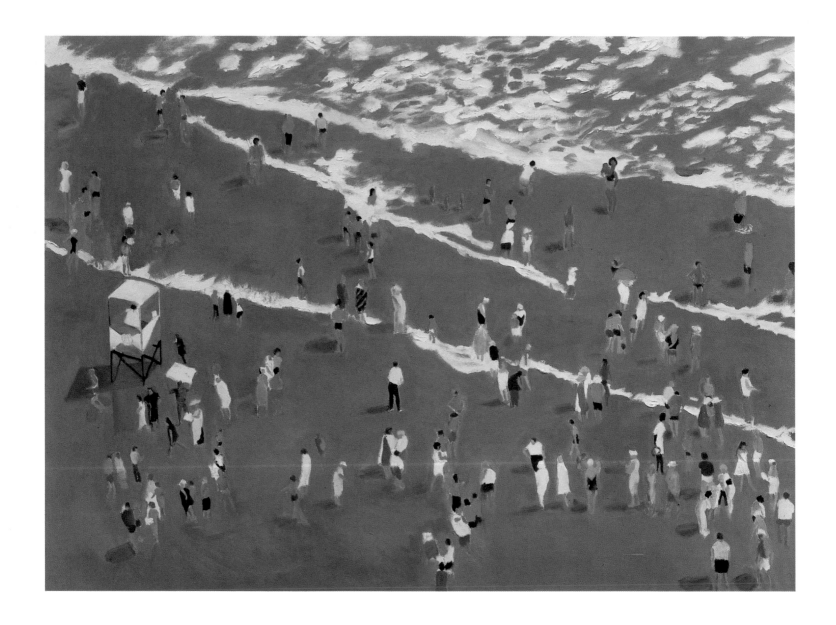

Atlantic City
oil on canvas
30 x 40 inches

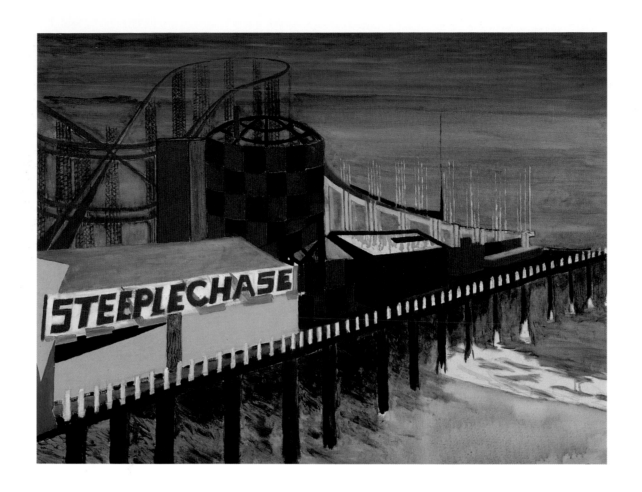

Old Steel Pier, Atlantic City
oil on canvas
30 x 40 inches

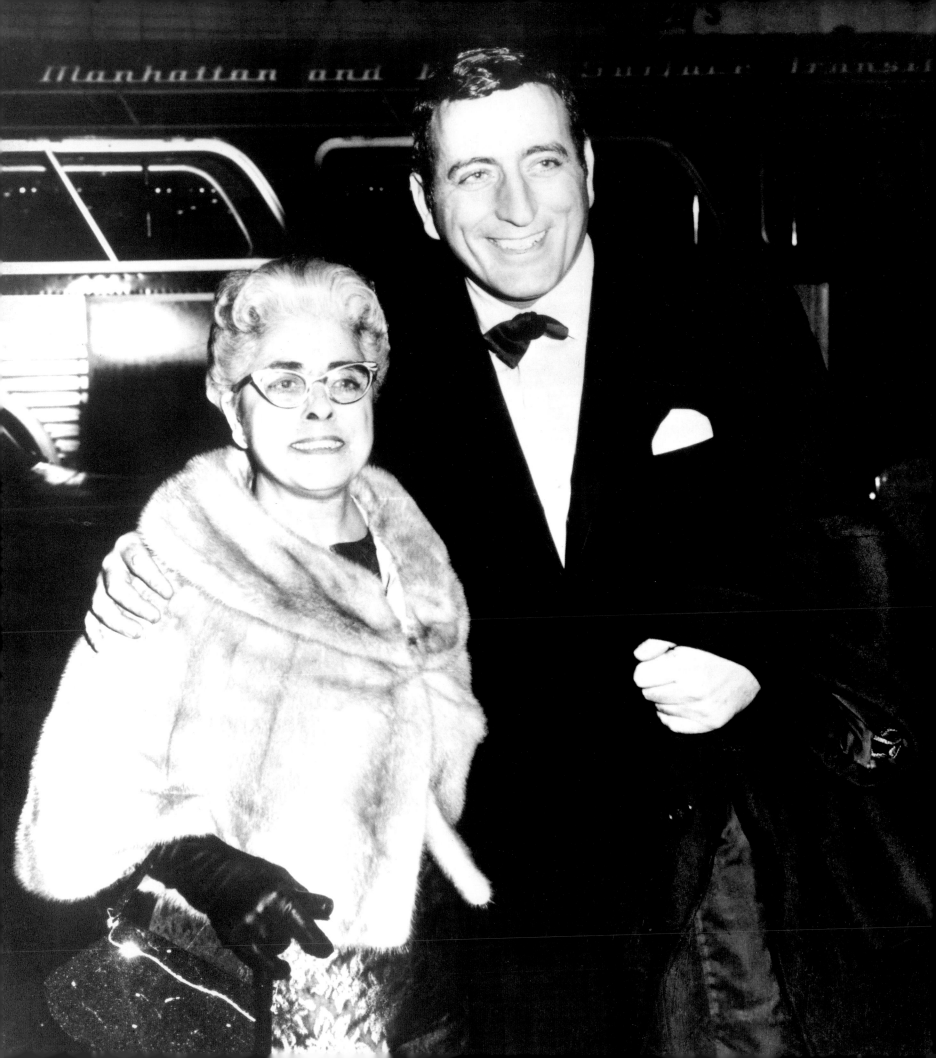

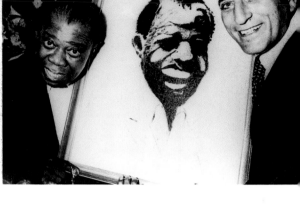

Portraits

*V*incent Van Gogh said that the eyes are the windows to the soul. If that is true, then I've been fortunate to catch a glimpse of the souls of the talented people and performers I've had the pleasure to paint.

Looking at a portrait, usually the first thing that strikes you is the resemblance of the painting to the subject. But I want to go beyond likeness towards a deeper texture than either surface or edge can convey. Interpreting a song is similar to painting a portrait—you might say the lyrics are the windows to the songwriter's soul and by studying the lyrics I try to capture the essence of each song and make it my own. Then, when I perform the song, the audience can feel an emotional connection to what I'm singing, find a special meaning for themselves, and feel that I am singing the song directly to them. It is the same with my portraits: I try to capture the subject's inner spirit. I want the viewer to catch a glimpse of the subject's soul.

My body of portraits includes several people who have left an indelible mark on their particular fields. To paint these portraits was a challenge and a labor of love. Take, for instance, Duke Ellington, the man who everyone in the music business—or the business of music—acknowledges as the most

Left: Tony escorts his mother to a gala event. Above: Louis Armstrong receives the portrait painted in London.

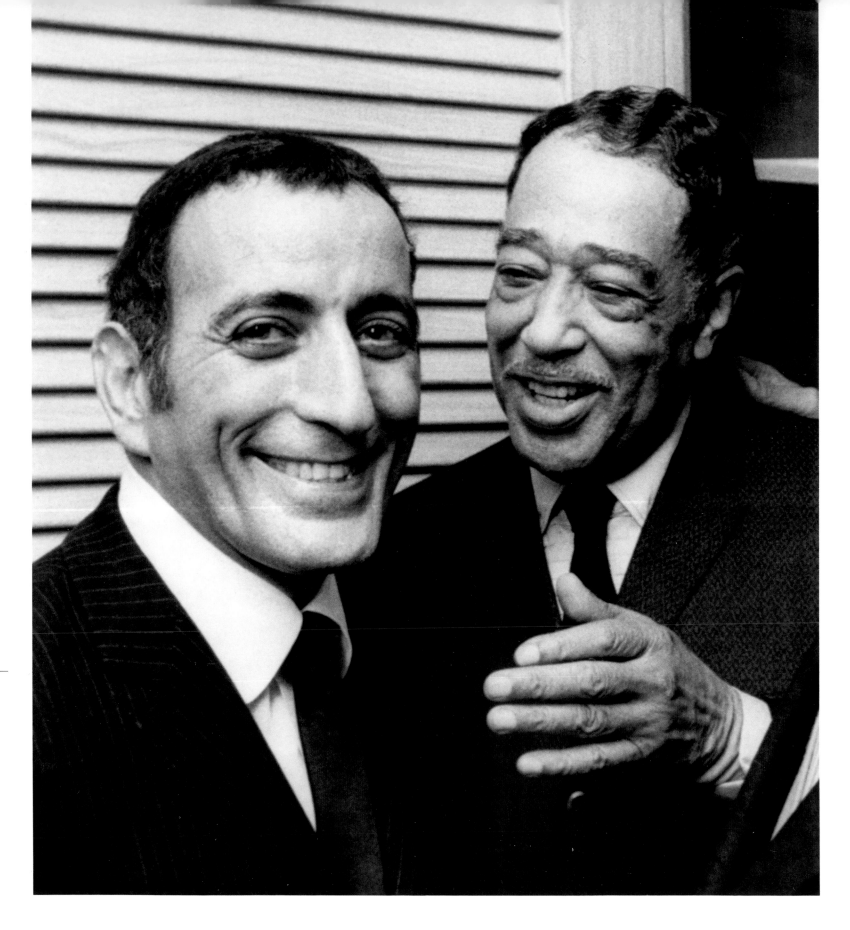

innovative and creative composer of jazz and the fountainhead of this genre. I cherish the memory of singing with Duke's band for several engagements and I got to know him well. When I worked on his portrait, I was inspired by the look of divine serenity on his face. His sense of knowledge and worldliness comes through in his music. When you look at the portrait, you will see roses strewn around the canvas. There is a reason for this. In his later years, whenever he composed a new piece of music, he would send me a small bouquet of roses to mark the occasion. I included the roses in my portrait of Duke in memory of this great man.

Another portrait I enjoyed working on was that of Frank Sinatra. Frank has been an inspiration to me both as a singer and as a man. Right from the early days of my career he has always encouraged me and has offered me many words of wisdom. I once asked his advice about the kinds of songs I should sing and he said, "Sing the good songs and you'll never go wrong." With a twinkle in his eye he gave me the truest and also the most challenging advice I've ever heard. Frank's portrait was fun to do. The cocky grin, the quasi-tough attitude, the glinting eyes—put them all together and you get the dean of popular singers, Frank Sinatra. As a tribute to him I recorded a musical portrait called *Perfectly Frank*, with my versions of the songs that Frank Sinatra made famous. I was thrilled when the album was awarded a Grammy for Best Classic Pop Record of 1993.

Left: With Duke Ellington who created "America's Jazz Age." Above: With K.D. Lang in 1994.

Painting the portrait of Fred Astaire was another great pleasure. I was living on the West Coast for a short time when I first met Fred and, quite honestly, I was in awe of the man. When he told me that he enjoyed my recordings, his genuine warmth swept away my shyness. Everyone remembers him best as a sensational dancer, but Irving Berlin and the Gershwins always chose Fred Astaire to introduce their new material. I wonder how many people know what a fine singer and great interpreter of songs Fred Astaire was. But what I most admired him for was his dedication to his work and his determination to perform a dance routine as brilliantly as possible. Ginger Rogers once said that he sometimes rehearsed until his feet would bleed and even then he would say, "Once more, please." When it comes to ratings, he is up there on a very high shelf.

As you look at these portraits, you'll see a collection of singers, dancers, musicians, and several people who are simply my great friends. It has been a delight to paint them.

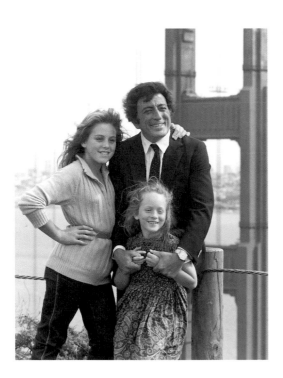

By the Golden Gate Bridge with daughters Johanna and Antonia.

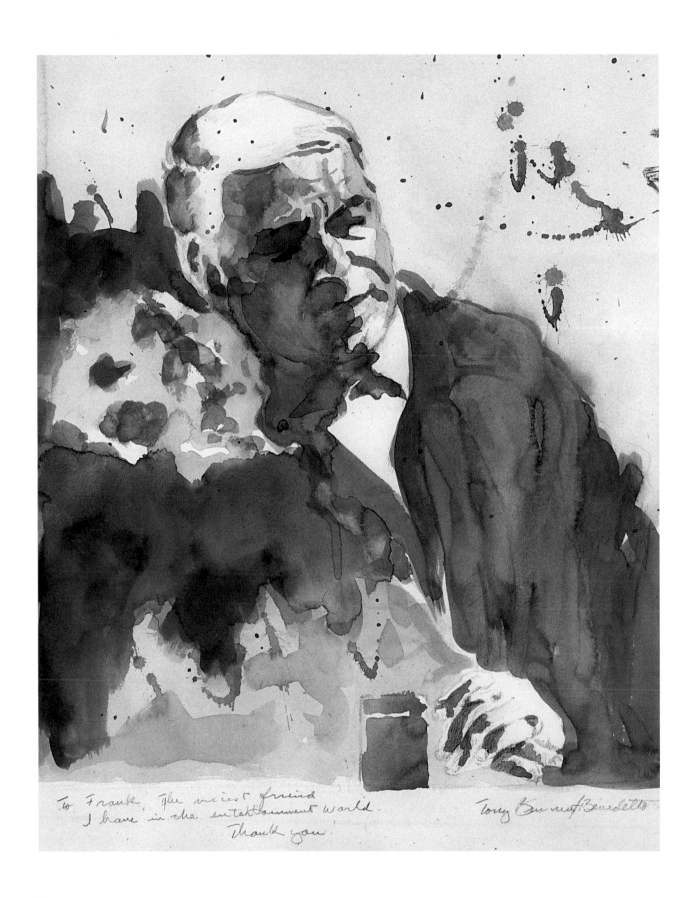

To Frank, the nicest friend
I have in the entertainment world.
Thank you. Tony Bennett Benedetto

Sinatra
gouache
19 x 17 inches

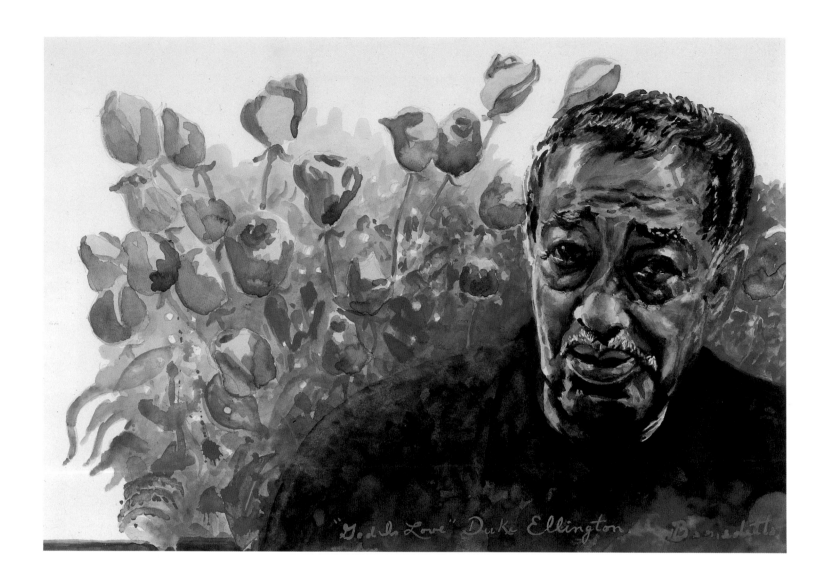

"God Is Love" Duke Ellington

Duke Ellington "God Is Love"
watercolor
14 x 20 inches

Dizzy Gillespie
oil on canvas
24 x 36 inches

Ella Fitzgerald
watercolor and gouache

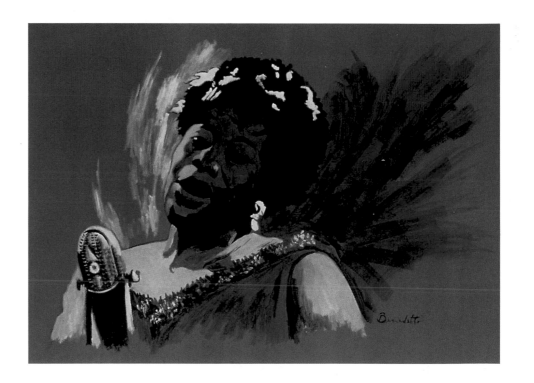

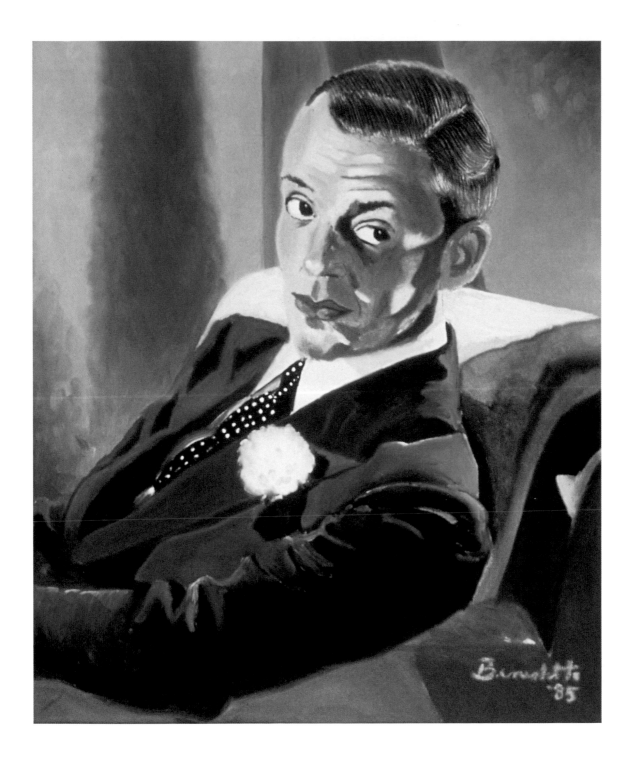

Fred Astaire
oil on canvas
24 x 20 inches

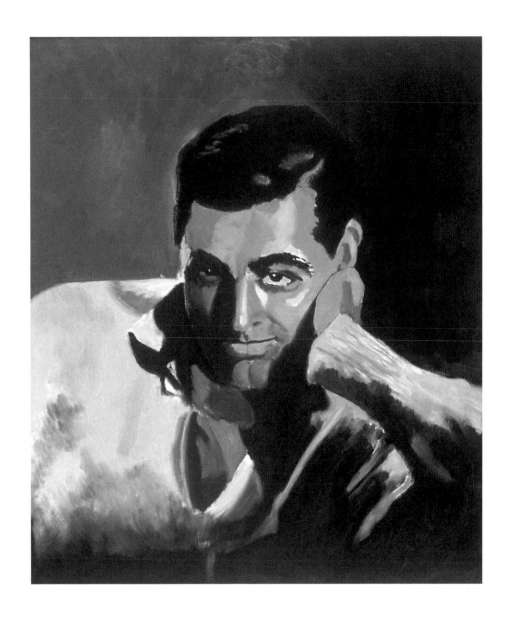

Cary Grant
oil on canvas
24 x 20 inches

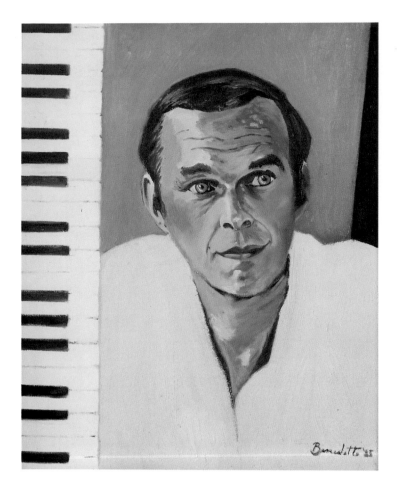

Ross Tomkins
oil on canvas
18.5 x 14.5 inches

Hockney
watercolor
16 x 11 inches

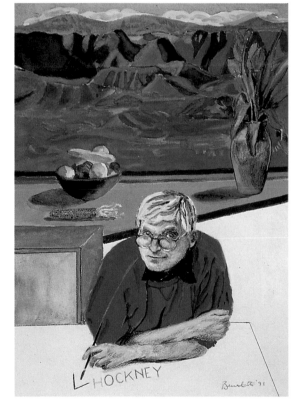

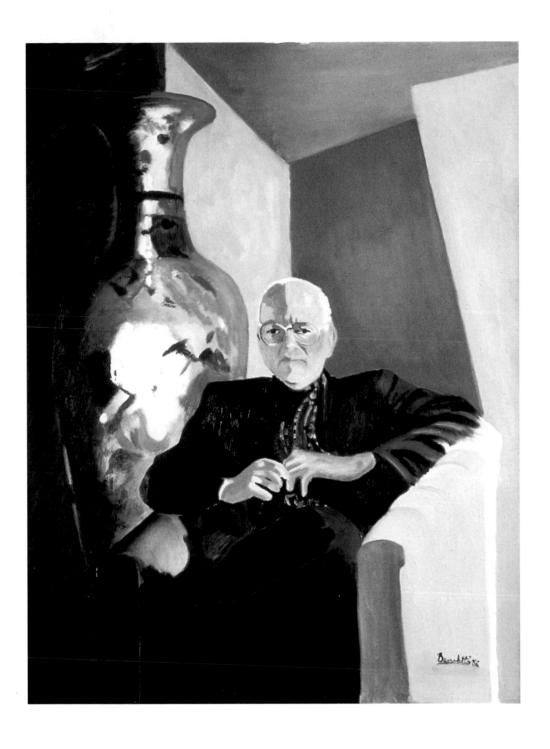

Ralph Sharon
oil on canvas
43 x 30 inches

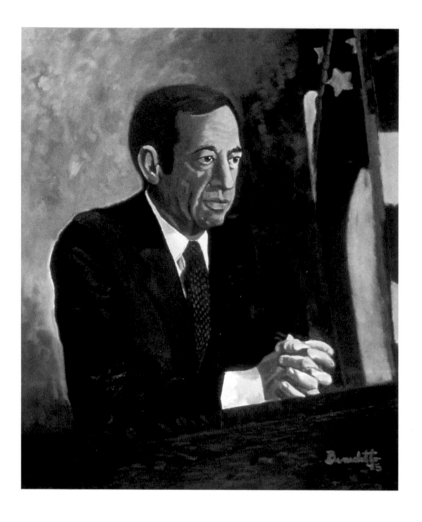

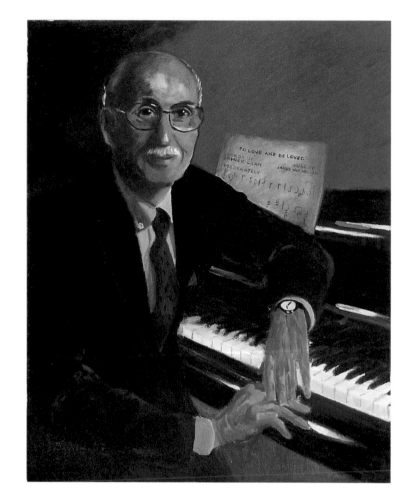

Governor Mario Cuomo
oil on canvas
36 x 30 inches

Sammy Cahn
oil on canvas
28 x 22 inches

Joanna
oil on canvas

My Daughter Antonia
oil on canvas
15 x 19 inches

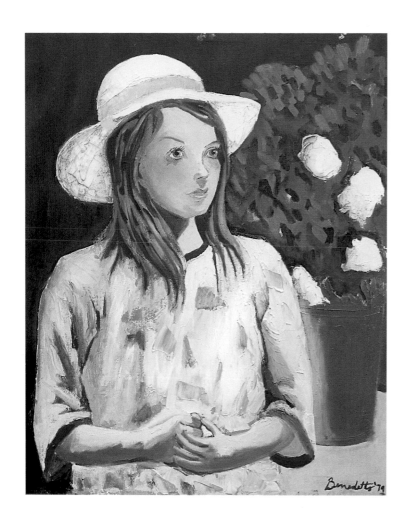 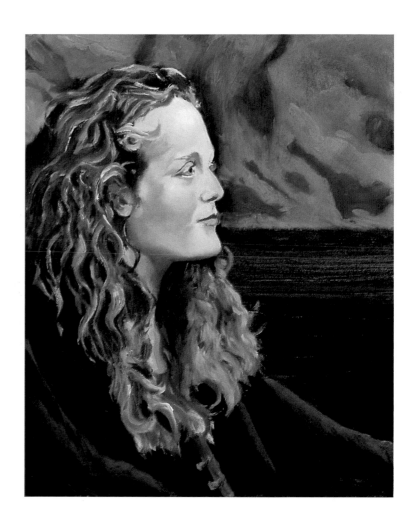

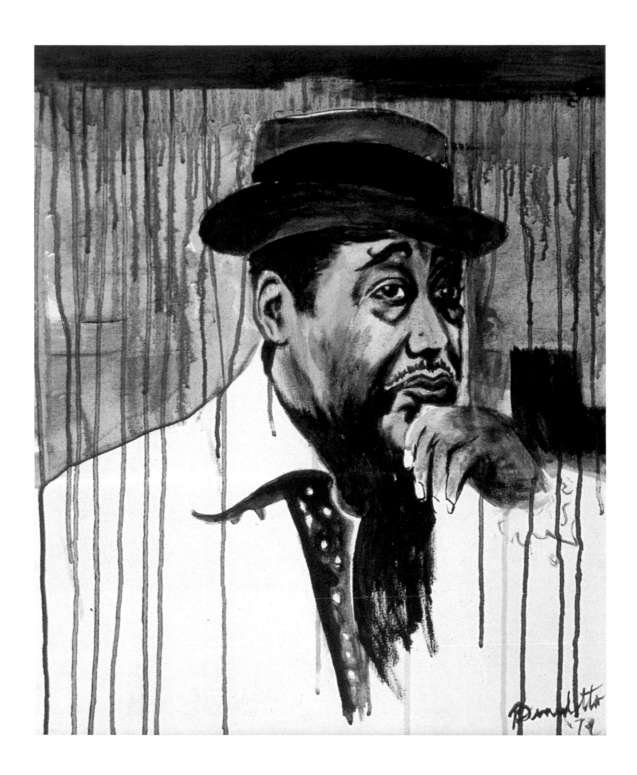

Duke Ellington–Black Rain
watercolor
24 x 20 inches

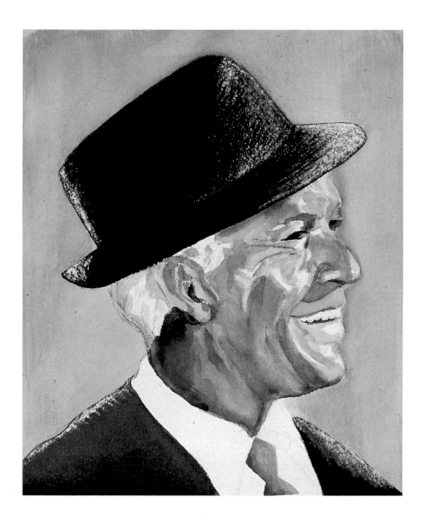

Perfectly Frank
watercolor
22 x 18 inches

Charlie Chaplin
watercolor
16 x 12 inches

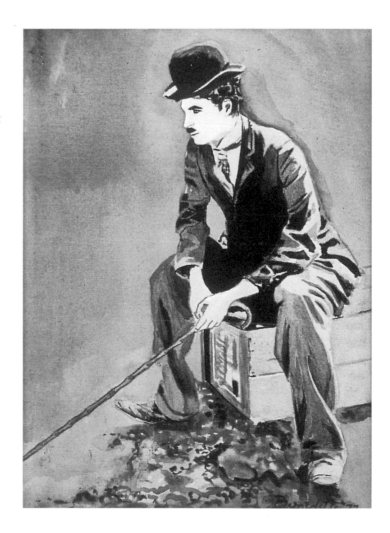

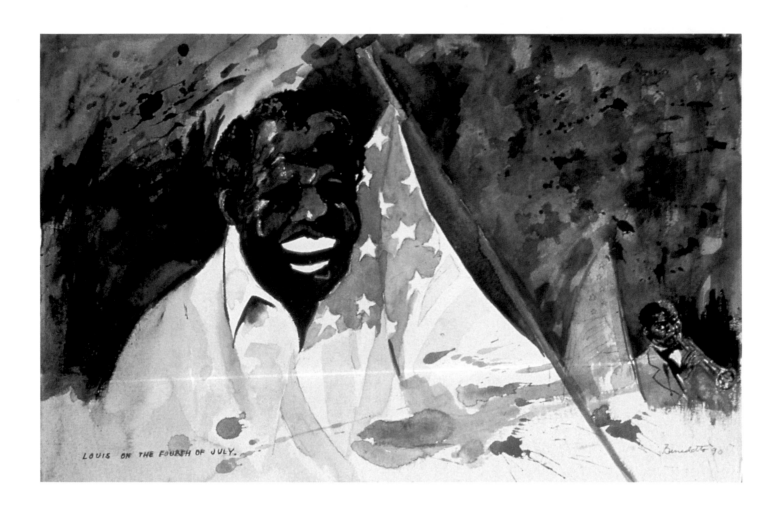

Louis on the Fourth of July
watercolor
18 x 22 inches

JIMMY HEATH....

"COUNT" BASIE

Benedetto

ED JONES.

Musicians and friends

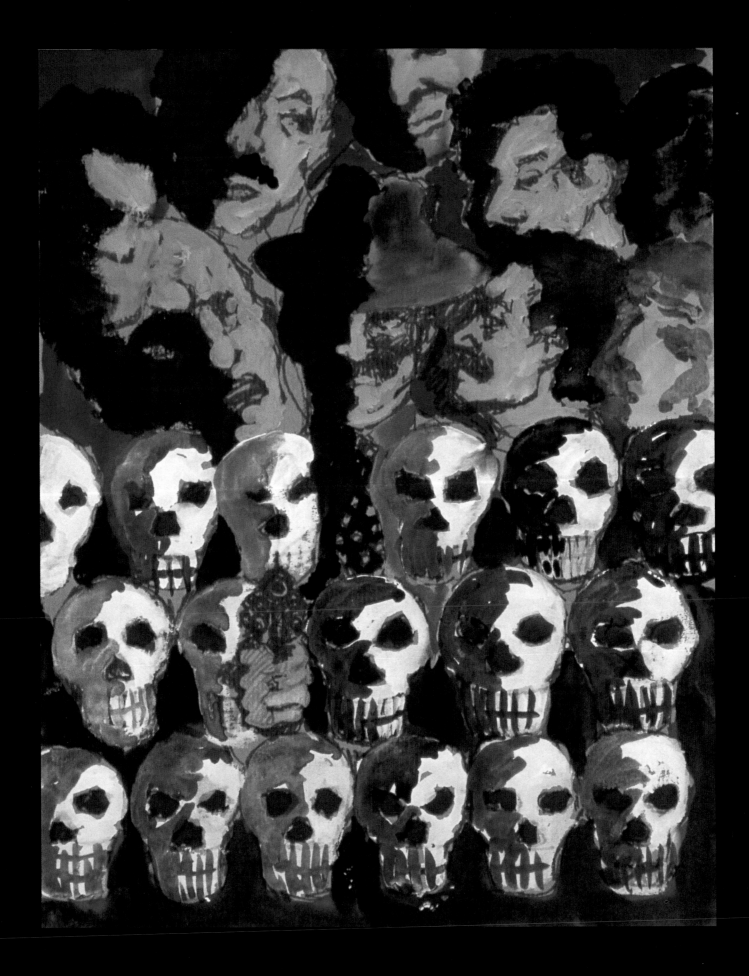

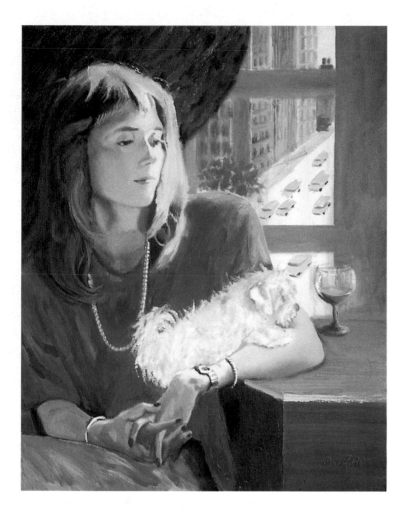

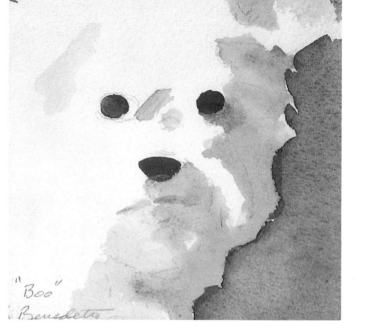

Susan Crow and Boo
oil on canvas
27 x 22 inches

Boo
watercolor
6 x 4.5 inches

The Underworld
watercolor
12 x 9 inches

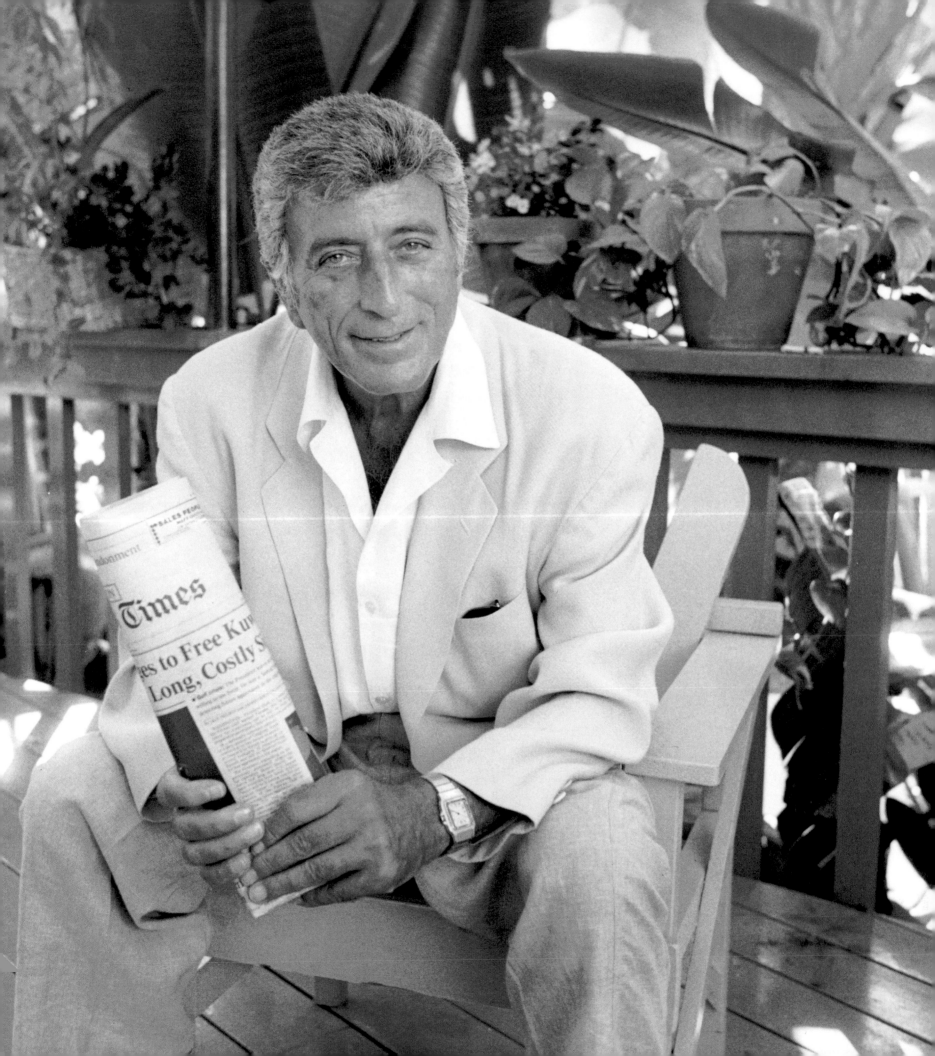

Still Life

*t*o most people a hotel room is a place to stay when on vacation or on a business trip. It is somewhere to rest between meetings and visiting tourist attractions and to get a night's sleep. I travel so much that a very large part of my life is spent in hotels. I'm not too demanding, but as I sketch and paint in my room, it is essential to have a room with good light. If I am confronted with a brick wall, then I'm out of luck. My special request, to quote both E. M. Forster and Noel Coward is "a room with a view." Grant me that, and with my paints and brushes I'm a happy man.

What I love about painting is that, as with music, you never know when the inspiration will strike. This is particuarly the case with still-life painting. There is no need to make an appointment to paint a still life, so when I have some spare time in between rehearsals and performances, it is both convenient and relaxing for me to sketch what I see around me in my room. The ordinary becomes my subject: apples in a fruit bowl, or the bowl itself, can occupy me for hours. A vase of flowers, a single flower from the arrangement, or just the vase, are all examples of the unlimited still-life subjects that are almost always available to me.

Left: Visiting David Hockney in Hollywood Hills, California, 1990. Above: Posing for the camera in 1927.

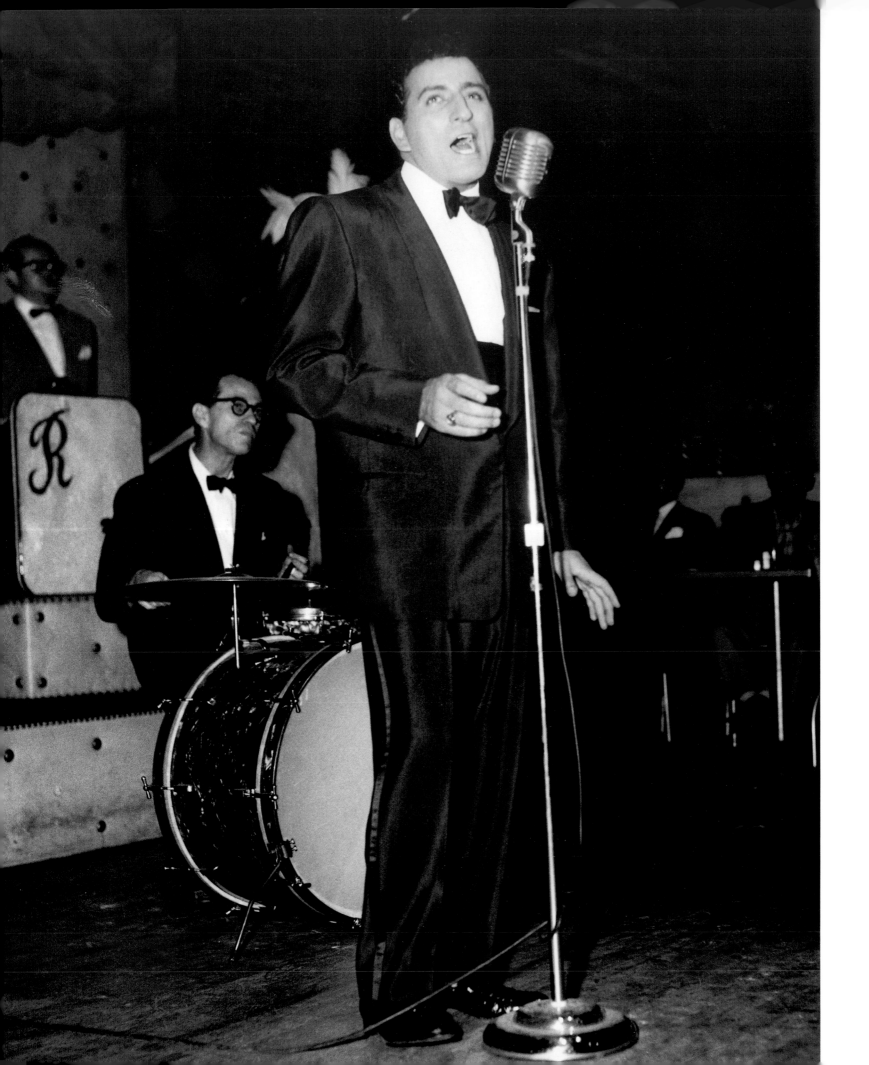

Among the still-life paintings that have made the greatest impression on me are those of that Edouard Manet painted in the last years of his life. Their small, luminous flowers are brilliant and jewel-like. I also greatly admire the still lifes of Paul Cézanne. With geometric shapes and voids for the viewer to fill in, the paintings appear to contain air — they breathe. Among my contemporaries, David Hockney certainly has influenced my own still-life painting to the greatest extent.

"The World Is Full of Beautiful Things," by Leslie Bricusse, from the film *Doctor Doolittle,* is one of my favorite songs and it is quite meaningful to me. I have seen many of the world's wondrous things, and I have joyously reproduced them on canvas. With these still-life paintings I am best able to express "what my heart has seen."

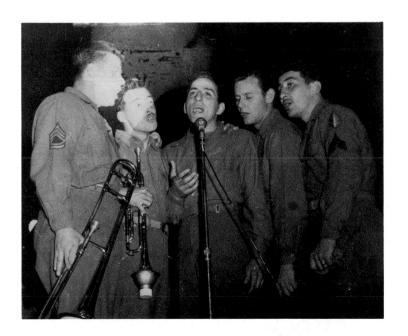

Left: A performance with Billy Exiner. Right: Tony with an army quartet in Germany at the end of the war.

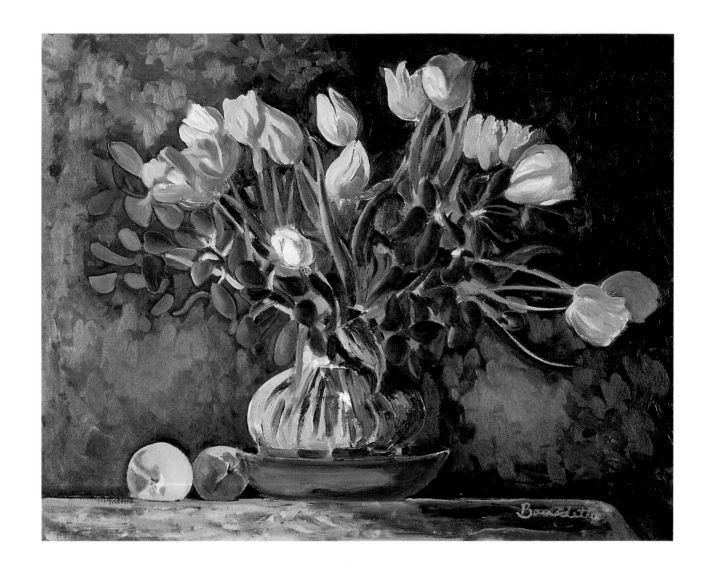

Flowers in Vase
oil on canvas
24 x 30 inches

Homage to Hockney
oil on canvas
36 x 24 inches

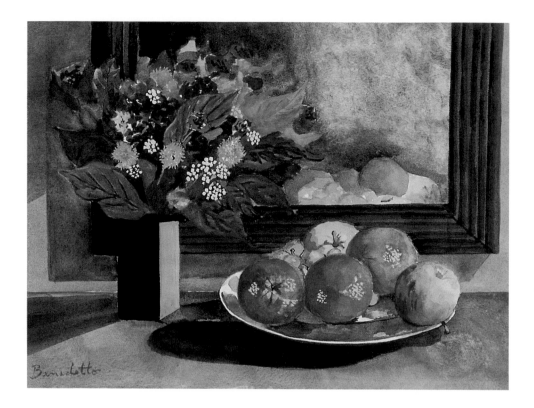

Still Life in Mirror
watercolor
12 x 16 inches

Still Life
oil on canvas
30 x 24 inches

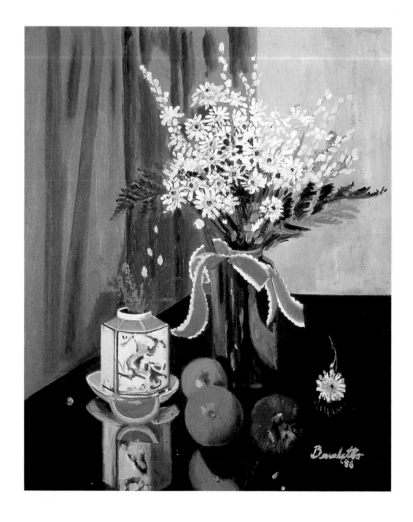

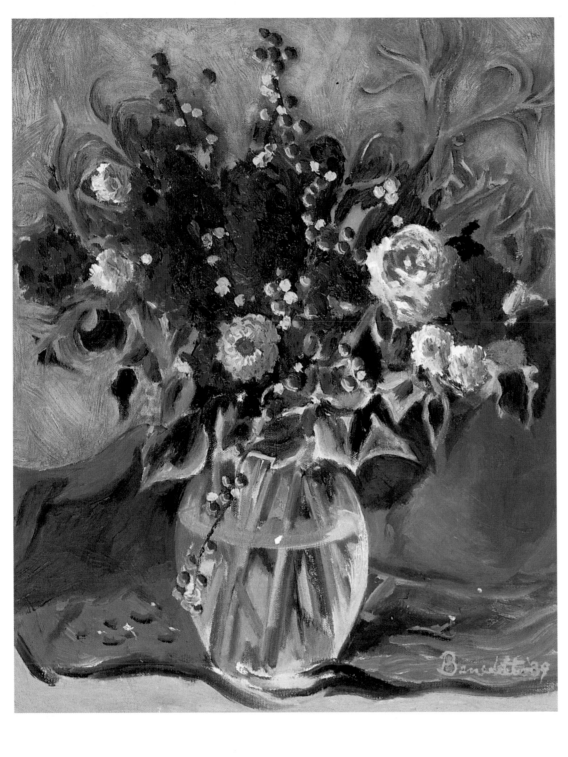

Still Life with Flowers
oil on canvas
20 x 16 inches

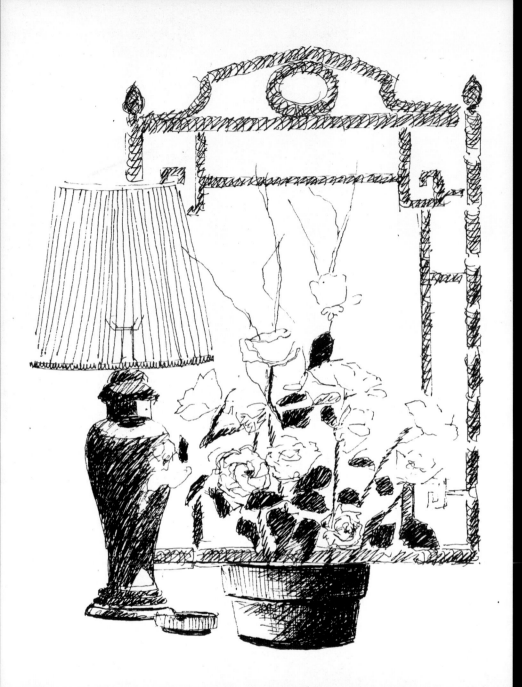

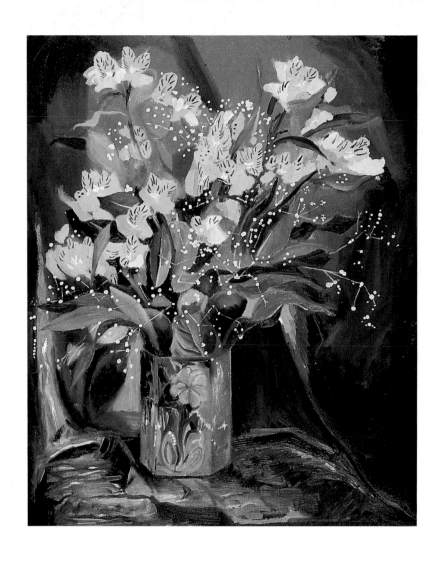

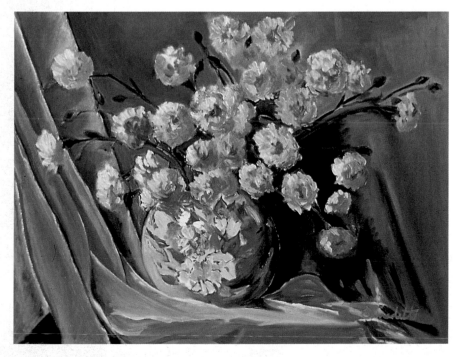

**Still Life with Vase,
Pink Flowers**
oil on canvas
28 x 22 inches

Still Life with Yellow Flowers
oil on canvas
24 x 30 inches

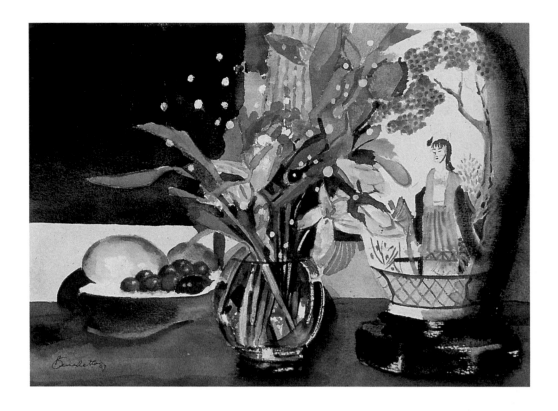

Chinese Vase No. 1
watercolor
11 x 15 inches

Chinese Vase No. 2
watercolor
12 x 13.5 inches

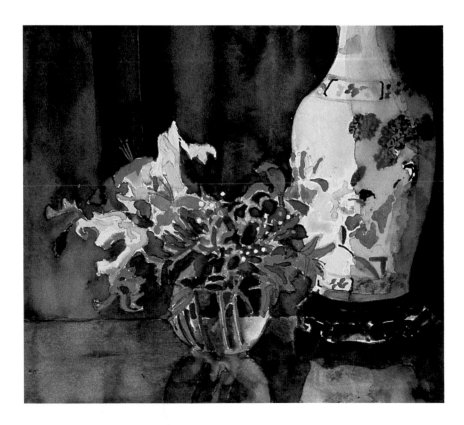

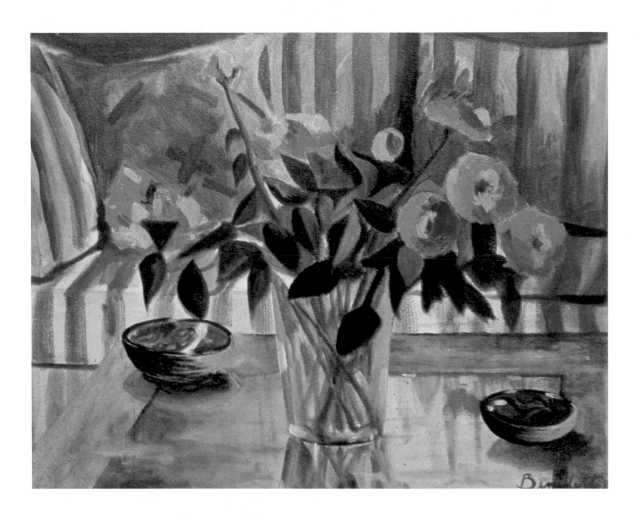

Flowers VI
oil on canvas
24 x 30 inches

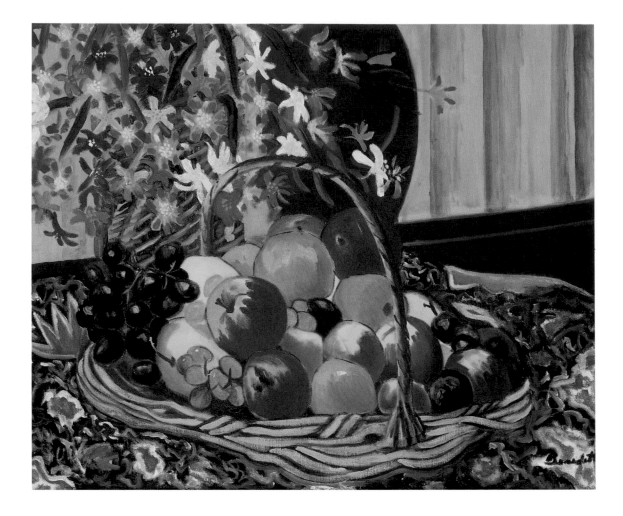

Still Life
oil on canvas
20 x 24 inches

Teapot with Sliced Apples
oil on canvas
16 x 20 inches

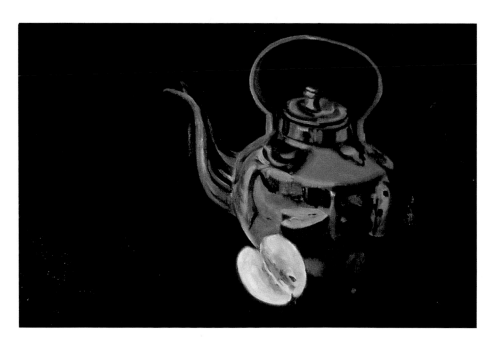

Still Life with Teapot
oil on canvas
20 x 16 inches

The Painter

i have been inspired through the years by many artists, including my first art teacher, James McWhinney, and Professor John Barnicort in London, who gave me some valuable lessons. Other artists whom I would like to acknowledge include Rudy DeHarak, Basil Baylin, Chen Chi, and Betty Fraser. Everett Raymond Kinstler, one of America's greatest portrait painters, has taught me so much.

At his suggestion I abandoned oils for quite a long period, and what I discovered by concentrating on watercolor has been invaluable for every type of painting that I do. Kinstler's own portraits could be said to be illustrations rather than pictures of his subject. They offer more than likeness, they express the inner being.

David Hockney has reminded me that nature never lets an artist down. There is nothing better than painting in the open air. Sketching and painting in watercolor or gouache is easy out of doors. It is also by far the most convenient when traveling.

Early Bennett—Waiting for a session to begin at Columbia Records in the late 1940s..

In Las Vegas I used to occupy myself between shows by painting in my dressing room. One day I had just finished the painting *The South of France* when Cary Grant was ushered in. Cary was the most handsome, suave, and elegant man I have ever met. He often came to my Las Vegas shows and he would always stop by and say hello. At that first meeting he was really struck with *The South of France*. "I want to buy that painting!" Cary said. I told him I would be happy to give it to him as a gift, but he was determined to buy it, and he did. Several years later his widow invited me to their home and there on the wall hung my painting. Then I realized why he had insisted on that particular one. Through the open window I saw that his view of the Hollywood Hills was an uncanny replica of the scene in *The South of France*.

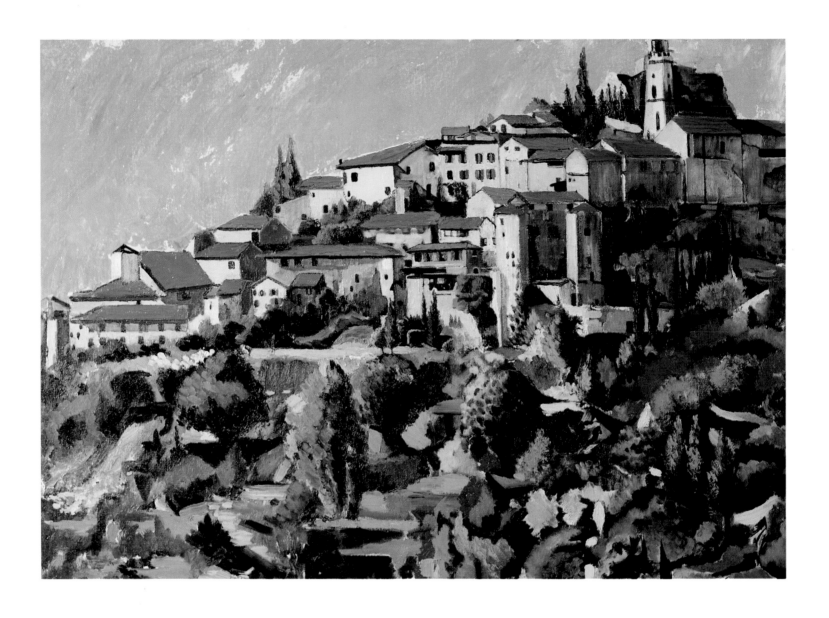

The South of France
oil on canvas
25 x 31 inches

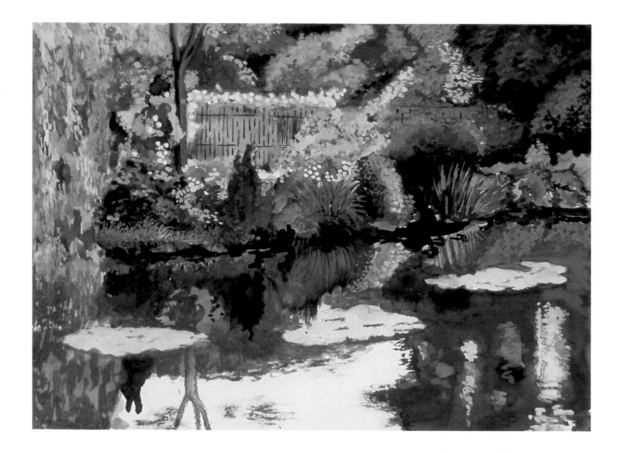

Monet's Gardens No. 3
oil on canvas
10 x 14 inches

Monet's Gardens No. 7
watercolor
11 x 15 inches

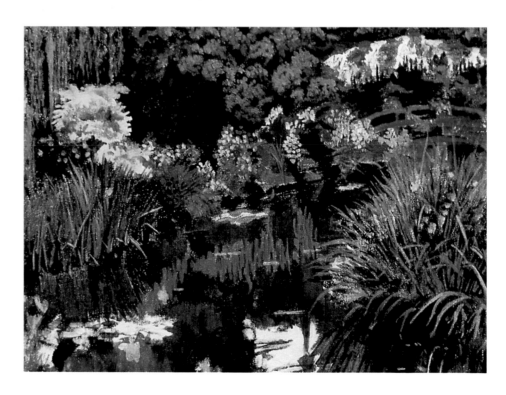

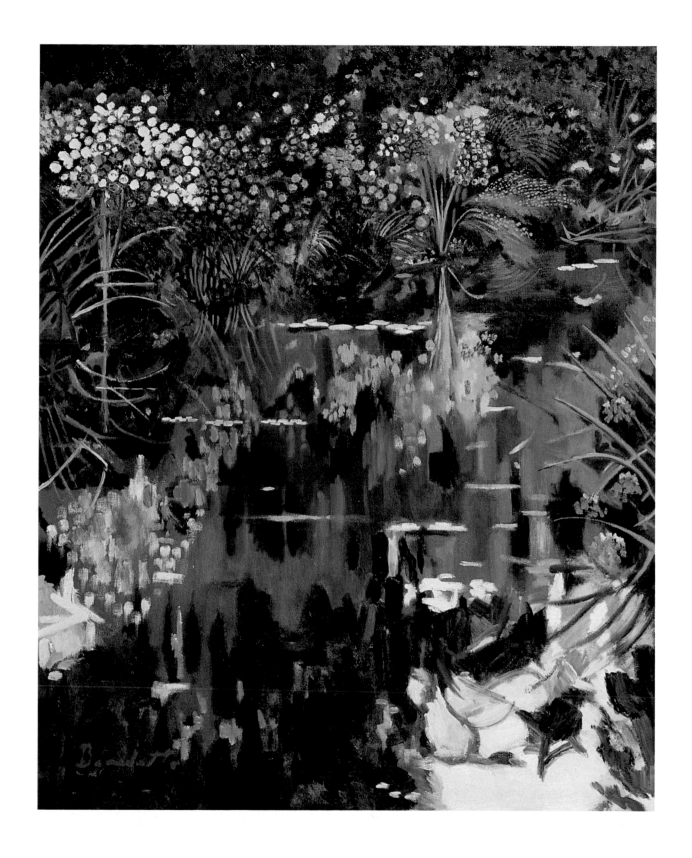

Monet's Gardens No. 1
oil on canvas
40 x 30 inches

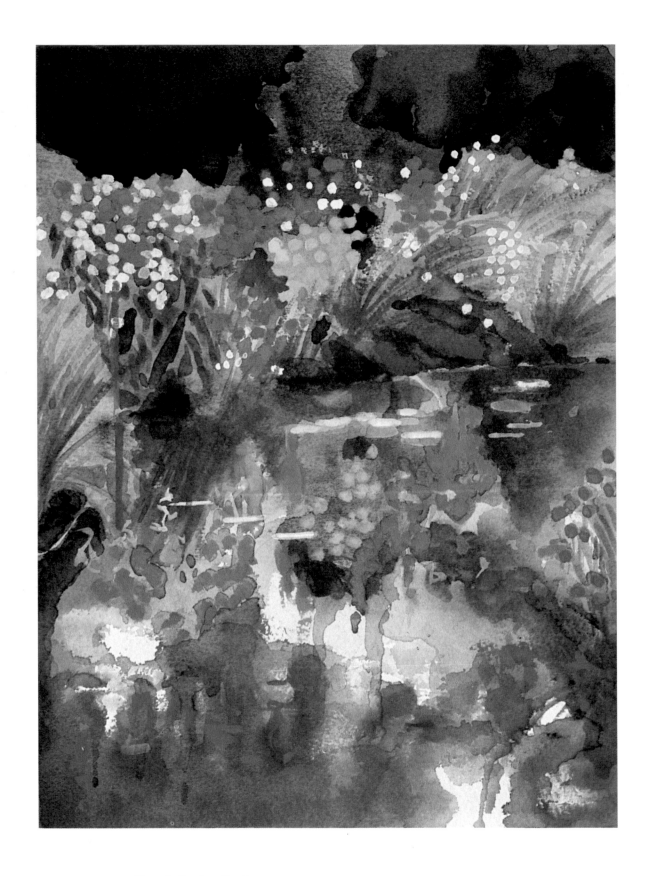

Monet's Gardens No. 6
watercolor
12 x 9 inches

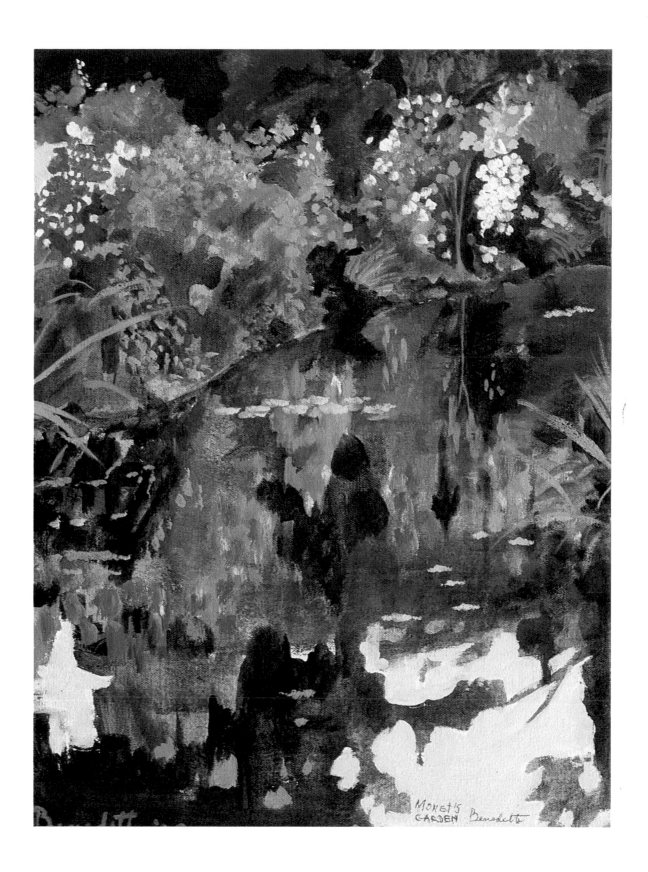

Monet's Gardens No. 5
oil on canvas
14 x 10 inches

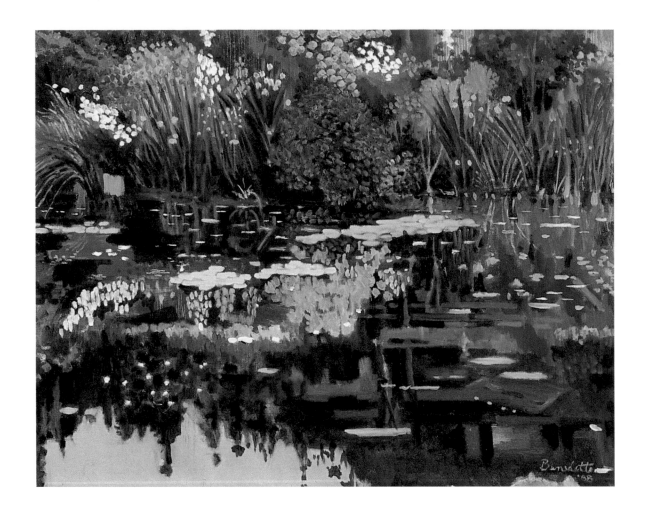

Monet's Gardens No. 4
oil on canvas
10 x 14 inches

Monet's Gardens No. 2
oil on canvas
30 x 40 inches

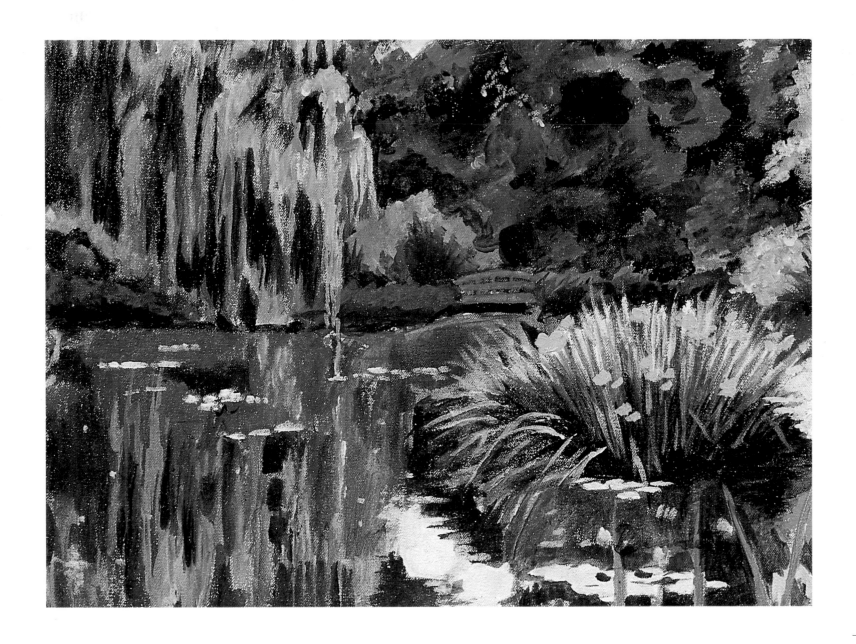

Photography Credits